IMAGES
of America
EDMONDS
1850s–1950s

ON THE COVER: Edmonds developed as an industrial city from the 1880s until the early 1950s. Due to the abundance of huge firs, cedars, and other trees, logging businesses and mills opened in downtown Edmonds. There were at least 14 mills on the waterfront, about four to the north and 10 to the south of today's ferry dock. Businesses thrived in the small downtown area, built up, changed hands, and multiplied. Most of the businesses lined Main Street, from the waterfront to the Edmonds Grade School on Seventh Avenue. (Courtesy of Edmonds Historical Museum.)

IMAGES
of America
EDMONDS
1850s–1950s

Sara McGibbon DuBois and Ray E. DuBois

ARCADIA
PUBLISHING

Published by Arcadia Publishing
Charleston, South Carolina

Printed in the United States of America

Library of Congress Control Number: 2013957395

For all general information, please contact Arcadia Publishing:
Telephone 843-853-2070
Fax 843-853-0044
E-mail sales@arcadiapublishing.com
For customer service and orders:
Toll-Free 1-888-313-2665

Visit us on the Internet at www.arcadiapublishing.com

*In memory of John W. Wingate and everyone
else who ever lived in Edmonds.*

CONTENTS

ACKNOWLEDGMENTS

For the vintage photographs in this book, we thank the Edmonds South Snohomish County Historical Society and Museum and Tarin Erickson, director, and Caitlin Kelly, collections manager; Mark Sundquist, for sharing his own vintage postcards and photographs free of charge; the Everett Public Library's Northwest History Room's librarian/historians Lisa Labovitch and David Dilgard; the descendants of Josine Erdevig Stone, Christy Merwin and Steve Roe; and the Jolley family members now in two countries—Sandee, Lois, and Norman.

We also want to thank other libraries in the region, Edmonds and Lynnwood of the Sno-Isle Libraries and the Seattle Public Library. We received information from the Hibulb Cultural Center on the Tulalip Reservation in northern Snohomish County. We wish to acknowledge everyone who lived in Edmonds, going back 164 years, through 55 years ago, and even now. The authors are indebted to those who did and do live here. The lives of those who lived then and now have added to the very fabric of this history.

Thanks to one and all!

INTRODUCTION

The Indians came to this area to gather the cattails from the marshes for mats, bedding, and clothing. They came to hunt the game animals, which included deer, elk, bear, raccoons, and other mammalian wildlife. They fished the waters, dug for clams and oysters, and hunted for crabs in the beach areas. They camped nearby. In the summer, there would have been delicious blackberries, small huckleberries, wild raspberries, and Oregon grapes. Wild vegetables grew nearby, too, so they had all the healthy food they needed to get by. These Indians also built their permanent and temporary shelters, longhouses, and structures to store food.

George Brackett, the founder of Edmonds, was born in 1841 in New Brunswick, in eastern Canada. He was one of 20 children. Like his father, young George worked as a logger in New Brunswick and coastal Maine. In the late 1860s, he moved west in search of cheap timber and growing markets. He arrived in the Pacific Northwest in 1869 and found work as a logger clearing timber from present-day Ballard and Magnolia.

Brackett dreamed of founding a lumbering town with readily accessible timber, abundant fresh water, and safe moorage. But the coastline north of Seattle was mostly steep hills and bluffs, and thus not conducive to what he had in mind.

In 1870, while exploring Puget Sound by canoe, he was forced ashore by high winds. Coming onto a sandy beach at what would become Brackett's Landing Park, he saw acres of low-bank shoreline covered with timber and riddled with freshwater streams. The water off the beach was deep enough for ships to come into a pier. He returned to Seattle to complete the Ballard logging operations, but never forgot what he had seen.

He returned two years later and paid $650 for 147 acres of beach and prime timberland. It was the first concrete step in realizing his dream. Within a few years, he built a small wharf at the foot of today's Bell Street and soon added a sawmill and loading dock near the site of the present-day ferry terminal.

Despite being small and inaccessible to shipping traffic at low tide, Brackett's wharf served as the only boat landing in Edmonds for many years. When a fire destroyed the mill in the early 1890s, the wharf escaped the flames. It continued as Edmonds's primary moorage until 1902, when City Wharf was completed at the foot of Main Street. Today, all traces of Brackett's wharf are gone. The last rotting pilings were removed in 1988 to make way for the breakwater at Brackett's Landing Park.

Before Brackett came to this location, there were a few other settlers, among them Pleasant Ewell, who moved shortly after Brackett bought the tract of land. When Brackett's Landing became more settled, the town was christened Edmonds, presumably for an admired political person of Brackett.

Once Brackett was established, the town grew. Many newcomers arrived and got things going. The Matthew Hyner family, the Mowats, the Yosts, John Lund and the Deiner family, and the Andersons are among the founding settlers.

Logging business and mills soon opened in Edmonds. People got jobs in the mills and were able to learn trades. They came to earn money and eventually built up the town. Mills burned down and were rebuilt, changed ownership, and kept right on going through the late 1940s. The last mill shut down in 1951, and the whole waterfront view was forever changed.

A new one-room schoolhouse was created in 1887, but classes were conducted before that, in the Brackett family's barn. The Edmonds School District No. 15 began with two schools, the grade school and the high school. More grade schools were added, and in the late 1950s, a new high school was built, the old one becoming Edmonds Junior High. Lynnwood Junior High was also established. As more families with children moved to the area, the schools changed their looks and sizes to accommodate the growth. Of the first children to graduate from Edmonds High School, a few became teachers. There was a large number of teachers for the students.

Boats of various kinds were the first mode of transportation for Edmonds. People used canoes and rowboats individually. Then came the so-called Mosquito Fleets of steamers and stern-wheelers, and, after that, small and large ferries. Today, Washington State Ferries ply the entire Puget Sound region.

Edmonds's Main Street was home to shoe stores, cafés, and restaurants, the Princess Theater, a confectionery, pharmacies, real estate and insurance agencies, and newspaper offices. There were heating businesses, clothing stores, a Carnegie library, small department stores, and taverns. Establishments were also to be found on the waterfront—boathouses and marine supply stores, the railway station, and boat rentals. Churches and boardinghouses, apartment buildings, and specialty shops lined Main Street in the early days of Edmonds. The town continues to thrive as a bustling arts community and a tourist attraction, especially on the weekends.

There have been many wonderful prominent citizens, and a few that were less prominent but still colorful. The years have seen entertaining mayors and city council members as well. Some residents died young, from sudden illnesses or by the hand of another person. Local history is full of interesting people and events, and those of us who record some of that history are fortunate that there is such a rich supply of information to be had.

The chapters of this book include events, people, and interesting tidbits about Edmonds. Perhaps, one day, I will have the opportunity to expand on what is in this book and go into much more detail. Or, if not, perhaps other authors will carry on the next stories of Edmonds, my old hometown.

One

PUGET SOUND INDIANS

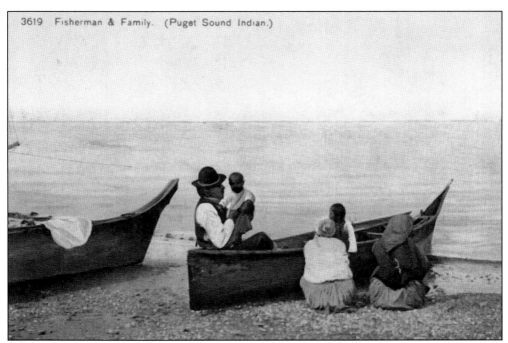

3619 Fisherman & Family. (Puget Sound Indian.)

This local Indian fishing family consists of the husband and wife, a grandmother, and two small children. When fishing, the entire family would row out in a dugout canoe. A second canoe was made available to carry the catch. The fish were cut and cleaned, then prepared for drying. Some fish were preserved for later use. (Courtesy of Mark Sundquist.)

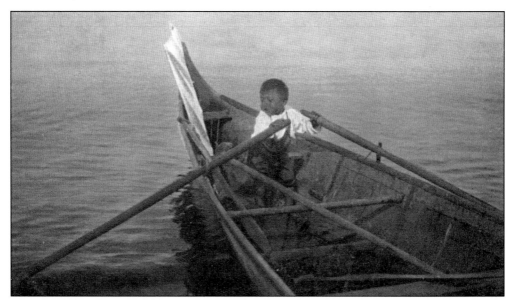

This very young boy may be learning how to row a boat, but he is doing so in safety. The canoe was beached, and the adults were working on the preparations at the camp. Children were allowed to play in the canoe and do pretty much whatever they liked, as long as the adults could see them and keep track of them. Often, even the youngest children helped out. (Courtesy of Mark Sundquist.)

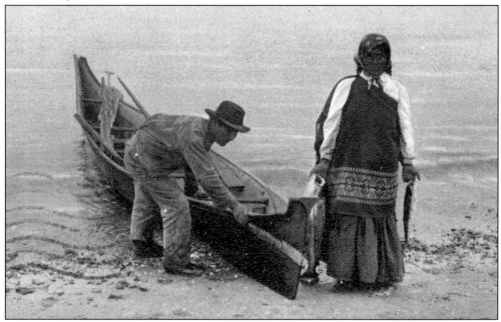

Both adults and children helped to unload the catch of fish, either by hand or in baskets made of cattails or cedar bark. Clams and other seafood were also placed in the baskets, making it easier to unload and carry the catch. Some of the handmade baskets were watertight and so could be used for cooking. The Indians could also dig pits in the sand and use hot rocks to cook the foods. They also searched for plants, including vegetables, herbs, and berries when they were in season. (Courtesy of Mark Sundquist.)

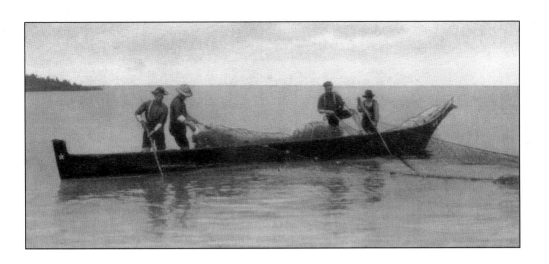

The Tulalip seiners were fishermen who used nets for their catches. Usually, a very large dugout canoe was used, and several men went out together, as the canoes, heavy and hard to row, required many men. In this way, too, several families could benefit from the catch of fish and seafood. An example of Tulalip large-group fishing is whale-hunting. It would take several men, in a very large and heavy dugout canoe, to row out to where the whales were. Then, it would take all of them to kill or capture the whale and get it to shore to be cut up and shared. All the whale's parts would be used, including the oil. (Both, courtesy of Mark Sundquist.)

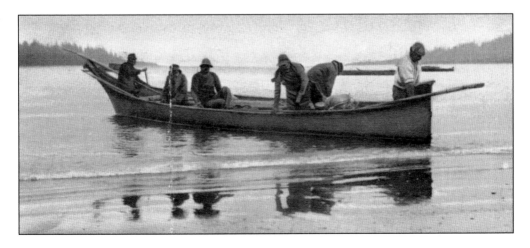

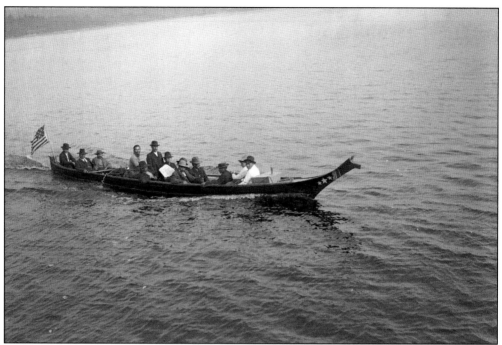

Tulalip Indians travel on Puget Sound in Nootka-style canoes, made by the various Coast Salish tribes in Washington and British Columbia. Nearly all of the tribes on the west coast of Washington are considered to be Coast Salish Indians, including the Snohomish, Swinomish, Suquamish, Skagit, Tulalip, and Lummi tribes. Native peoples located farther inland include the Puyallup and Skykomish, and one from south central Washington, the Yakamas. (Both, courtesy of Edmonds Historical Museum.)

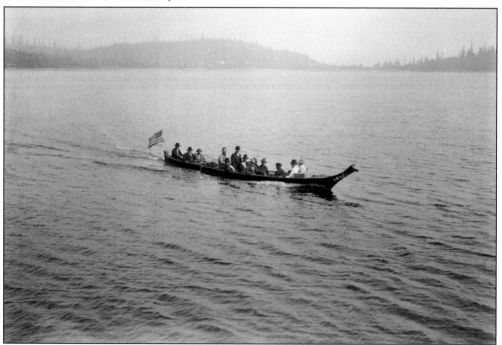

Here are two portraits of William Shelton, a cultural leader and liaison of the Tulalip tribe. He spent most of his 70 years dedicated to bridging the divide between regional Indians and whites through his storytelling and arts. He also worked with the Bureau of Indian Affairs and city officials, gaining their respect and support. He was intended to be an Indian shaman, but, at age 18, he decided that he needed to be educated in both Indian and Anglo American ways. He studied at the Tulalip Mission School, learning to read and speak English and receiving training in the carpenter's trade. (Both, courtesy of Everett Public Library, Northwest Room.)

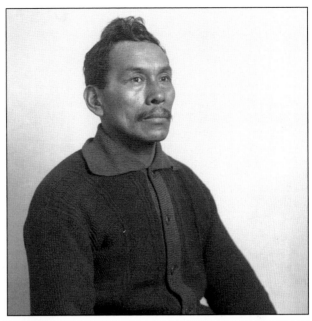

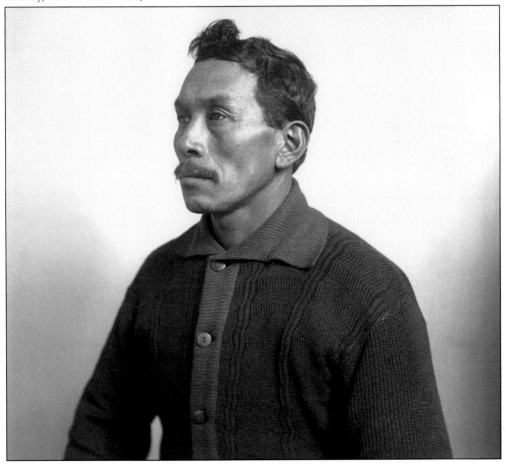

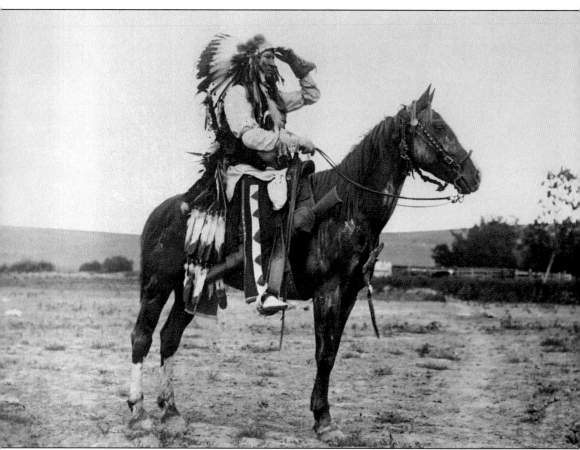

William Shelton and his family were goodwill ambassadors between what Shelton termed the races. He even liked to dress in his regalia and ride his horse for special shows and demonstrations. The headdress shown here is not Coast Salish regalia. Shelton was born about 1868 and lived until 1938. He and his wife, Ruth Sehome Shelton, were well-respected people. (Courtesy of Everett Public Library, Northwest Room.)

These photographs show the first "Spirit Quest" totem pole carved by William Shelton. It stood on the Tulalip Reservation for many years. Other poles he carved over the years were placed in downtown Everett and in Olympia, on the capitol campus. These story poles depicted spirit helpers, including humans, birds, and people encountered on spirit or vision quests by members of tribes from around the region. Shelton later recounted the stories he collected from the elders in published articles. "There is a broken link between my race and the white people," Shelton writes in "Indian Totem Legends of the Northwest Coast Country." The 1913 article was originally printed for an Indian school in Oklahoma and later appeared in the *Everett Herald*. (Both, courtesy of Everett Public Library, Northwest Room and the *Everett Herald*, January 3, 2012.)

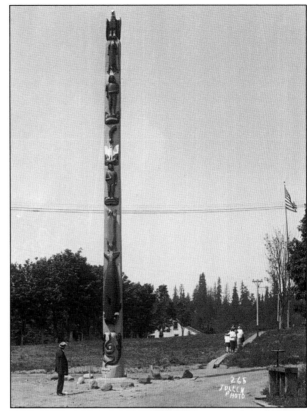

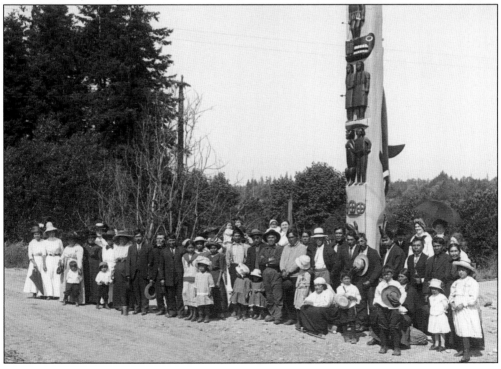

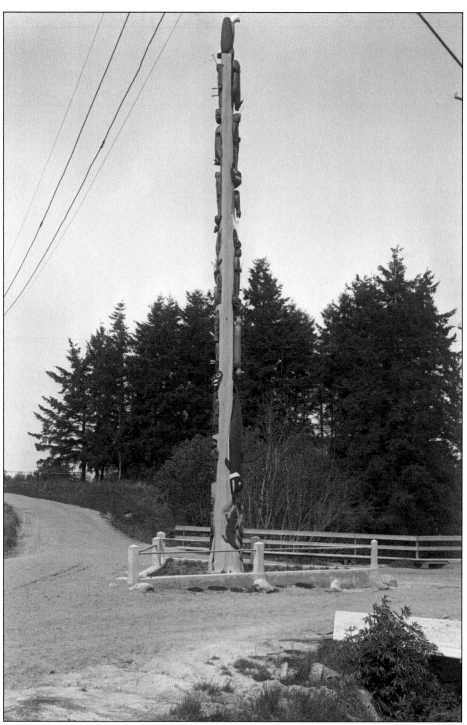

This is another photograph of William Shelton's spirit quest pole. Among other things, Shelton was a carpenter, a police chief, and the spokesman for his tribe. Besides creating totem poles, he told his stories to the elders, so they would better know their history. He also built the Tulalip tribe's first longhouse. (Courtesy of Everett Public Library, Northwest Room.)

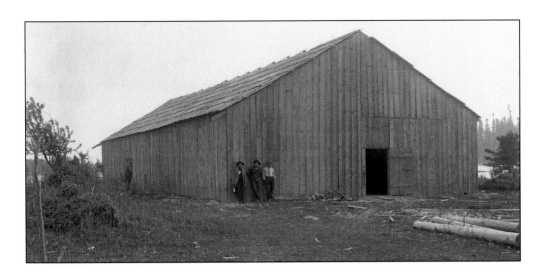

William Shelton built the longhouse shown on this page. In the above photograph of its exterior, three men can be seen standing in front. One of these men is reported to be Shelton. The below photograph, of the building's interior, also includes three men, sitting on a bench that is part of the special seating. Shelton may also be in this photograph. The opening in the roof allows smoke to escape when fires are burning. Longhouses were quite smoky 100 years ago, as there was no other heat source inside. (Both, courtesy of Everett Public Library, Northwest Room.)

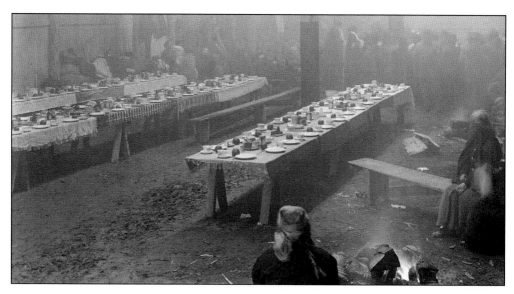

In order to celebrate the very first Treaty Days in the longhouse, on January 22, 1914, tribe members built and set up banquet tables at which the participants would dine. This auspicious day was celebrated by not only the people living on the Tulalip Reservation, but those in the other Puget Sound tribes, including members of the Suquamish, Swinomish, Skagit, Snoqualmie, Snohomish, Lummi, Skykomish, and Puyallup tribes, as well as the distant Yakama. John A. Juleen, a well-known photographer of the era, captured these scenes. Most likely, many of the families who came to celebrate also brought delicious dishes of game, fish, vegetables, and sweets to share. The event resembled a giant picnic potluck. (Both, courtesy of Everett Public Library, Northwest Room.)

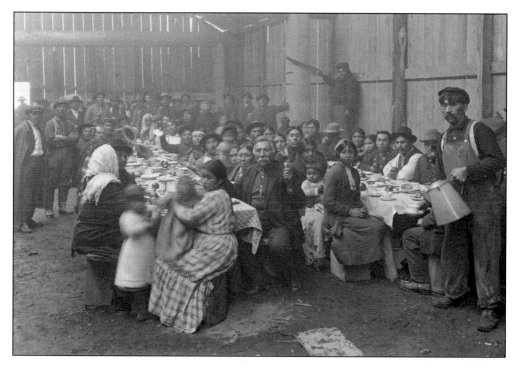

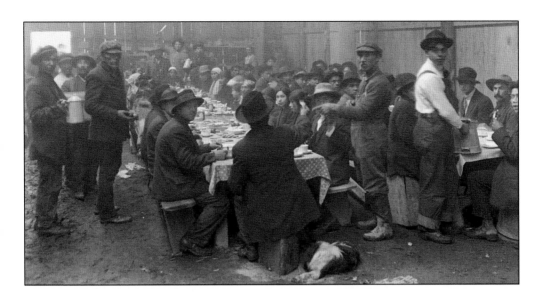

Shown on this page are two different groups of men. They are, for the most part, dining together. Often, but not always, the men were served first; and when they finished, the women dined with the children. At other times, everyone would eat together. If the groups were large, like at the first Treaty Day, shown here, there would probably be several groups. It would have probably been noisy and exciting at this time, with the Treaty of Point Elliott signed in January 1855. Unfortunately, the excitement would not last, because the United States government would later not honor this treaty any more than it had honored prior agreements. Hope was alive at the celebration, although, looking closely, there are not so many smiling faces. (Both, courtesy of Everett Public Library, Northwest Room.)

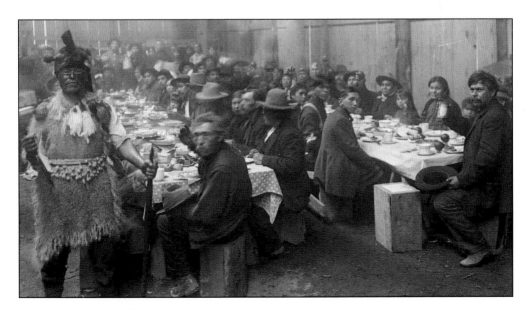

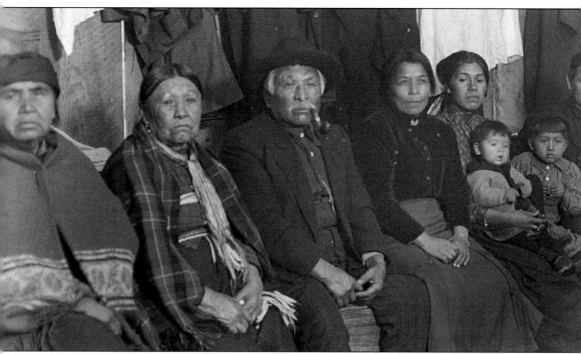

Indian elders sit in the longhouse on Treaty Days. These are the grandparents who are together on a bench. The grandparents also often helped care for their grandchildren. This 1914 photograph is one of many John Juleen took of this event to commemorate Treaty Days. (Courtesy of Everett Public Library, Northwest Room.)

Mothers tending to their children usually sat together so they could visit with one another. Not only did they care for the infants in their arms, but so did some of their older children. This assistance allowed mothers to keep track of their little ones as they played with other children. (Courtesy of Everett Public Library, Northwest Room.)

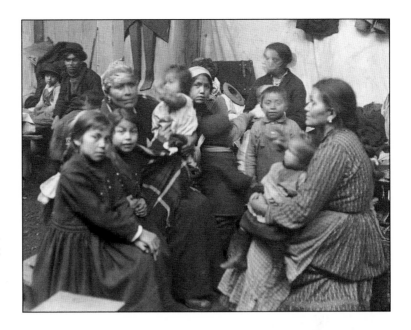

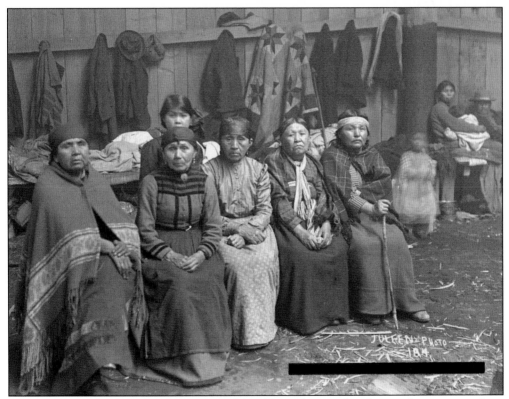

These women sitting on a bench are some of the elders. The grandmothers and aunts posing here are perhaps waiting for the rest of their families to come back from other areas of the longhouse. Note the beautiful outer dresses, the underskirts, and the shawls that many of them are wearing. (Courtesy of Everett Public Library, Northwest Room.)

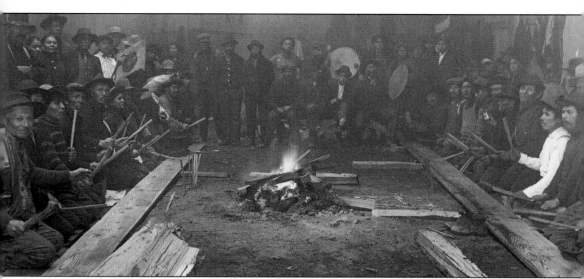

The Stick and Bone Game is highly competitive, and can go on for hours and even days. All ages can play. For the most part, it is played outdoors in the summer, but, as shown here, it can be played indoors, at any time of the year. Those who wish to play line up into two teams facing one another, and a leader for each team is chosen. An equal amount of money is gathered from the teams' players and held during the game. The team chosen to start hides a plain bone in a hand, and the other side has to guess which hand it is in. There are four bones, two marked with a carved design and the other two without. With each wrong guess, the winning side throws tally sticks to the losers. When all 10 tally sticks are gone, the team with none wins. The winning team gets the money, which is divided equally among the members. Tribes everywhere play this game at powwows. (Courtesy of Everett Public Library, Northwest Room.)

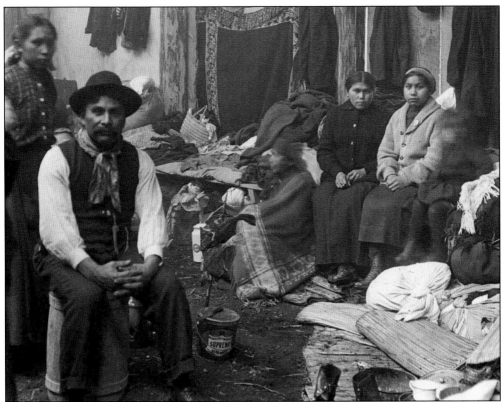

This group, preparing to leave the Treaty Days powwow, received many gifts from the potlatch, a special giveaway of items from the families and their friends who hosted the powwow. In the early part of the 20th century, items given away were usually homemade blankets, baskets, and other useful things. Today, the gifts are usually inexpensive items purchased by the hosts. (Courtesy of Everett Public Library, Northwest Room.)

These four unidentified elder men, standing in front of a tent, are at the work party picnic on the Tulalip Reservation. Perhaps, these elders explained to the others what needed to be done on this work party, or they may have been consulted about the work. The elders were very respected by the younger men and women. (Courtesy of Everett Public Library, Northwest Room.)

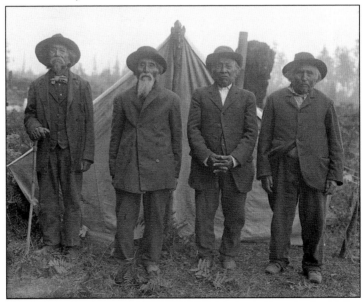

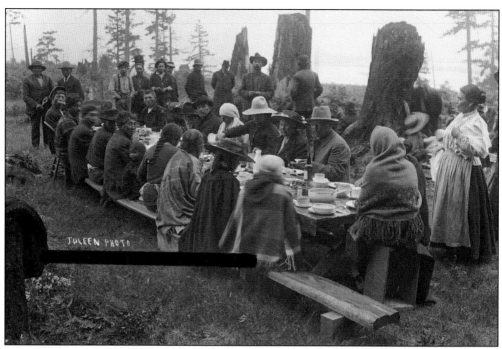

The above photograph shows a group of women, men, and children eating at the long banquet, or picnic, table. Shown below is a second, nearly equally mixed, group. At least one of the elders seen on page 23 is in the below photograph, sitting on the bench nearest the photographer. They are all part of the work party. The flowers visible at lower left indicate that this event took place in late spring or early summer. Note that some of the women are wearing shawls for warmth. (Both, courtesy of Everett Public Library, Northwest Room.)

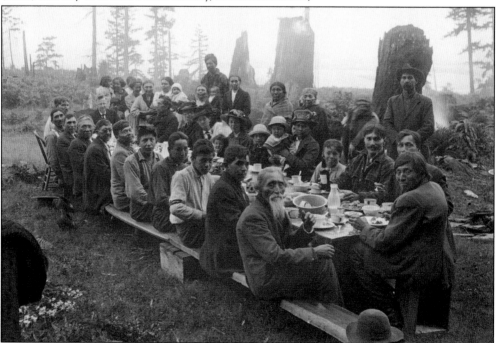

Two

FOUNDING FATHERS, MOTHERS, AND FAMILIES

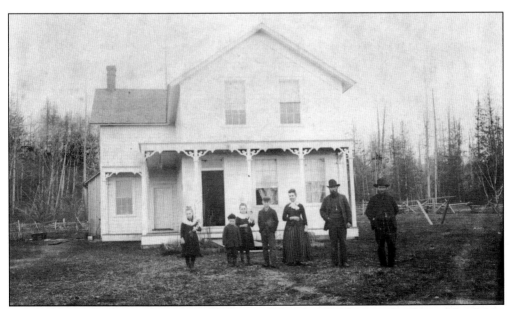

George Sumner Brackett and Etta Jones Brackett and their four children stand in front of their home around 1890. The home stands at what is now the corner of Second Avenue North and Edmonds Street. The family includes, from left to right, Nellie, Ronald, Fannie, George Jr., Etta, and George Sr. An unidentified relative stands at far right. (Courtesy of Edmonds Historical Museum.)

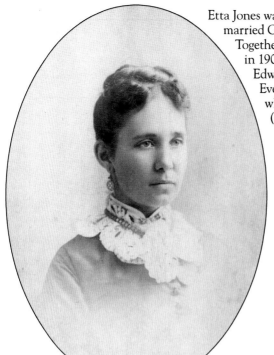

Etta Jones was born in 1859 in Willmar, Minnesota. She married George Brackett on June 20, 1877, in Seattle. Together, they had six children. The couple divorced in 1905, and on November 12, 1907, Etta married Edward D. Carpenter. They lived in Edmonds, Everett, and then in National City in California, where she died on May 12, 1934, at age 75. (Courtesy of Edmonds Historical Museum.)

George Sumner Brackett was born in New Brunswick, one of 20 children. His life's work was in logging, so, when he discovered a great place to do just that and then start a town, he did. The site was initially called Brackett's Landing, but the name was later changed to Edmonds. The 140-acre plat he purchased in 1876 cost $560. (Courtesy of Edmonds Historical Museum.)

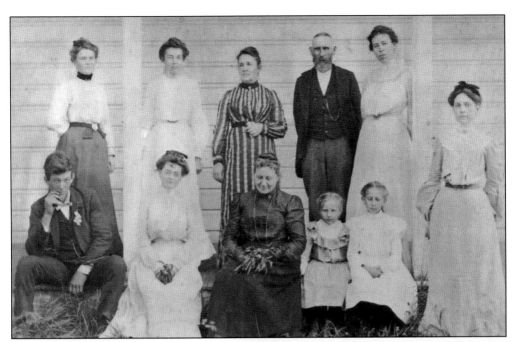

Members of the Brackett family stand on their side porch. In the back row are Etta (third from left) and George Sr. (fourth from left). Also shown here are their two grown daughters, a daughter-in-law, a grown son, and two young granddaughters. This photograph may have been taken sometime around the turn of the century, before Etta and George were divorced. (Courtesy of Edmonds Historical Museum.)

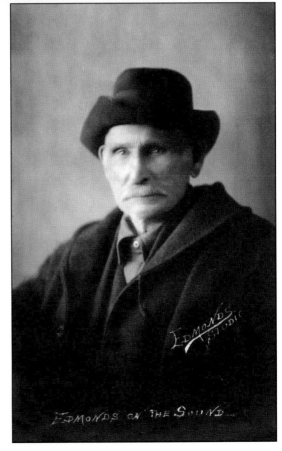

This 1926 photograph of George Brackett is one of the last taken of him before he died. It is the image that most often appears of him in publications about his life. (Courtesy of Edmonds Historical Museum.)

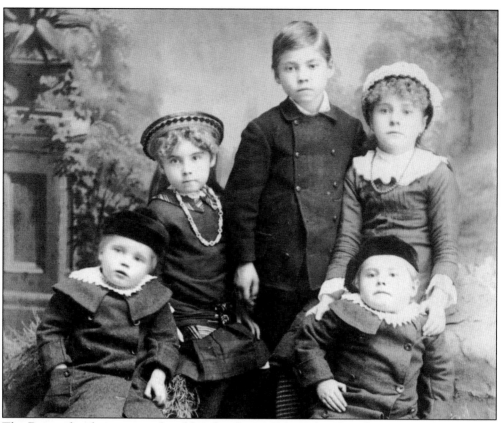

The Deiner family is among the oldest families in Edmonds. This photograph of the Deiner children was taken after their father's death. They are, from left to right, Oscar, three and a half, Annie, four and a half, Frank, seven, Flora, nine, and Harry, two and a half. Their father, Charles Deiner, died in August 1883, leaving their mother, Matilda C. Nelson Deiner, a widow and the children orphans. (Courtesy of Edmonds Historical Museum.)

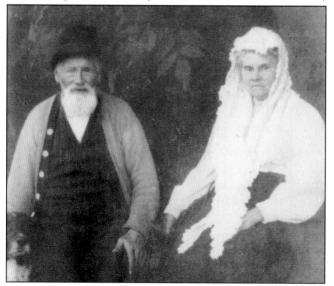

John Lund and Matilda Deiner married in the latter part of 1883. They lived in North Edmonds, in a section called Meadowdale. Lund would row the children to Edmonds on Sunday evenings, where they would board with another family, then be picked up again on Friday afternoon to have the weekend at home with their mother and stepfather. (Courtesy of Edmonds Historical Museum.)

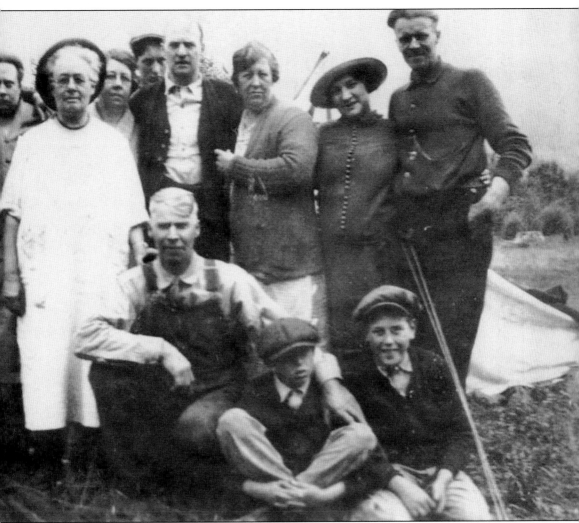

Frank Edward Deiner Sr. (first row, left), born in 1876, had three children—a daughter, Jessie, and two sons, Frank Jr. (first row, middle) and William (first row, right). Frank Jr. was born in 1906, and he and his wife, Sylvia Robson, had four children, including Gary, the third child. (Courtesy of Edmonds Historical Museum.)

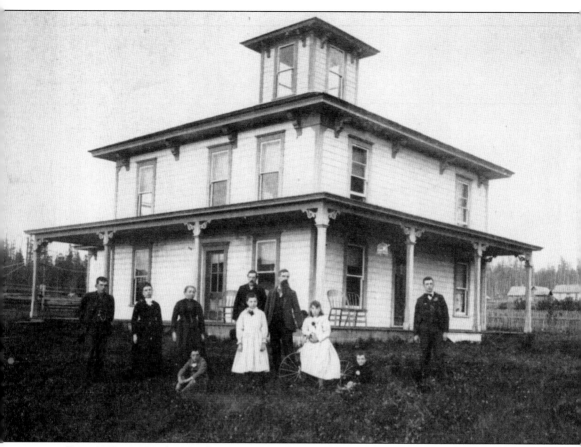

From 1887 to 1890, the Matthew E. Hyner residence had a "cupola which was used as an observation post for watching for steamers to come around Point Wells south of town or from Everett from the north." The Hyner store was the first general store, as well as the first post office, in Edmonds. Shown here standing are, from left to right, Will Brown, Flora Brown Smith Wellington, Clara Brown Hyner, Wellington Smith, Matthew E. Hyner, and Paul Hyner. The seated individuals are unidentified. (Courtesy of Edmonds Historical Museum.)

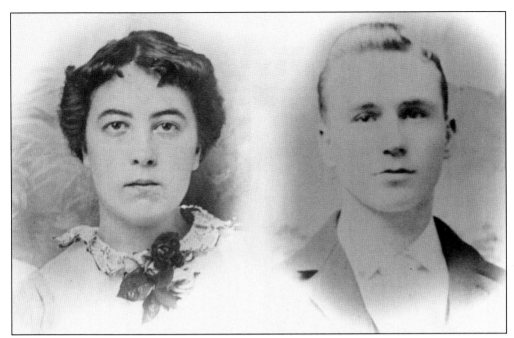

Ruth Hyner and Frank Hough are pictured here before their marriage. Ruth was born in 1877 to Matthew and Clara Brown Hyner; she was the third of four children. Ruth was one of the very first switchboard operators in Edmonds. Frank was born in 1876, the younger of two siblings. They married in 1903 at ages 25 and 26, respectively. (Courtesy of Edmonds Historical Museum.)

Frank and Ruth Hyner Hough are seen here with son Robert Frank Hough. Robert was the Houghs' only child. He was born in 1907, about four and a half years after his parents' marriage. Robert married, but apparently he and his wife, Jessie E., did not have any children. They lived in Marysville, Washington, east of the Tulalip Reservation. (Courtesy of Edmonds Historical Museum.)

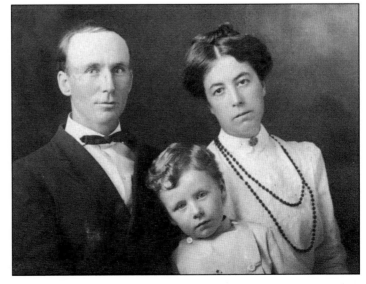

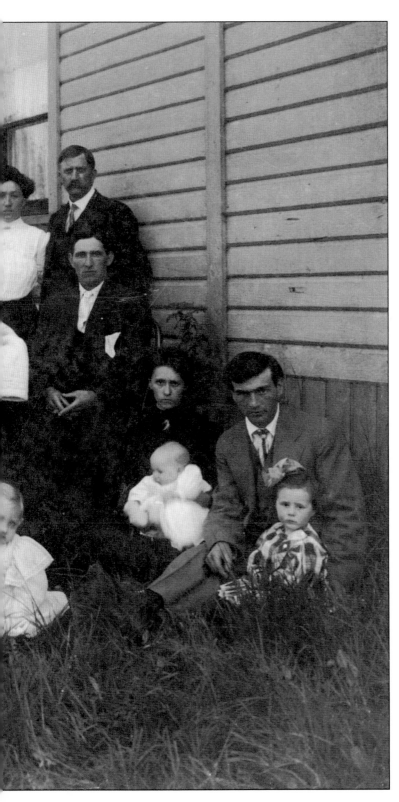

The Allen Martin Yost family, the Astells, and others gather on May 1, 1910. Shown here, in no particular order, are Amanda Yost, Allen Yost, Daniel Yost, J.M. Yost, Bessie Yost, Allan Yost, Joseph Yost, Lena S. Yost, Martin Yost, John Yost, Georgia Yost, Gladys Yost, Charlie Yost, George Astell, Carrie Astell, Lillie Astell, James Astell, Walter Russell, Elsie Russell, Joe Russell, Jacob Yost, Maud Yost, Irma LaMoione, Aletha Violet, Edward Yost, George Yost, and Samuel Yost. (Courtesy of Edmonds Historical Museum.)

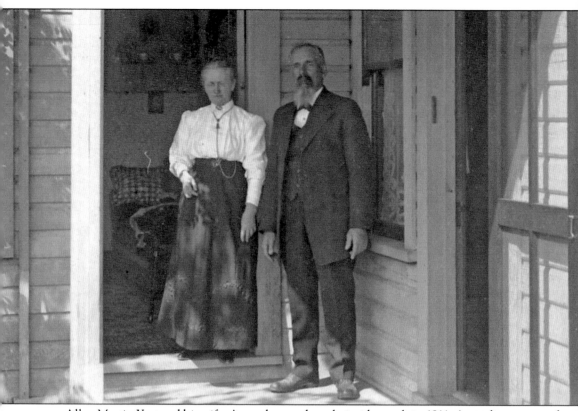

Allen Martin Yost and his wife, Amanda, stand on their side porch in 1911. According to one of Yost's great-granddaughter Patricia Susan Yost Longley, his actual name was Allison, not Allen. There has been no corroboration of this, so he is referred to here as history has documented him, as Allen. (Courtesy of Edmonds Historical Museum.)

Allen Martin Yost is seen here around 1913, two years before his death. (Courtesy of Mark Sundquist.)

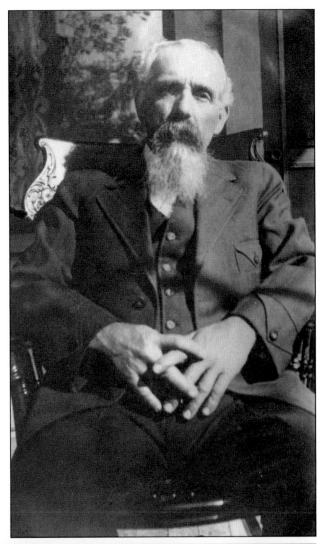

A.M. Yost's casket is seen on the opera house stage on August 19, 1915. Written on the back of the photograph is "Allen Martin Yost died at 1:15 p.m. on August 16, 1915, in Leavenworth, Washington, following an attack of apoplexy at age 59 years, 6 months and 17 days. Funeral services were conducted at the Yost Opera House in Edmonds on August 19, 1915. Yost was cremated at E.R. Butterworth & Sons, at 1921 First Avenue South in Seattle." (Both, courtesy of Edmonds Historical Museum.)

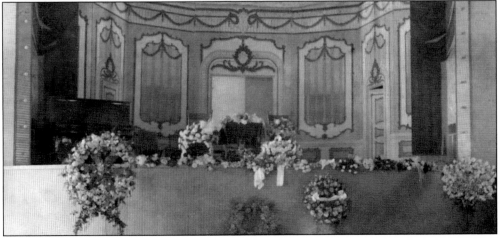

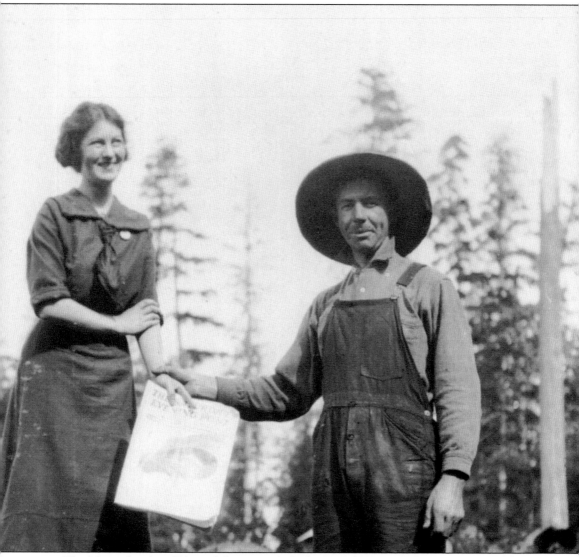

The Mowat family in Edmonds begins with Arthur Ward Mowat, born in Melbourne, Australia, in 1860. He married Lottie Diana Ruthven in 1888, and they moved to America. Ancestry.com research shows that the family, with five children, is recorded in the 1900 census as living in Edmonds. They owned a lumber mill, and Arthur was elected chief of the volunteer fire department in 1904. The first three children—Arthur Richard Gilbert, Jessie, and Annie—were born in Australia, but the fourth child, George L., was born in Canada, and the last, Harry, was born in Edmonds. (Courtesy of Edmonds Historical Museum.)

Three

LOGGING, MILLS, AND SHINGLES

Fir Log "Washington".

The loggers usually used horse teams and buggies outfitted with skidders (resembling sleds) to carry the logs that were cut down to a usable size. Instead of horses, oxen and mules could be used as draft animals. All of these animals were capable of handling the same-sized loads. Horses, however, could skid the logs both up and down slopes. (Courtesy of Mark Sundquist.)

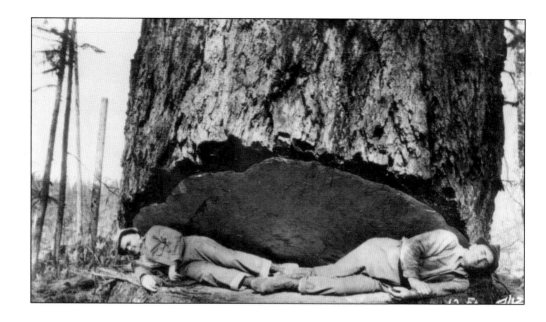

In the above photograph, a Douglas fir undercut, 12 feet in diameter, can accommodate two men lying down. Dancing would have been fun on one of the 12-foot-diameter or larger stumps, as seen below. This activity required that at least someone have a violin to play popular music of the day—in this case, the 1880s or 1890s. Participants could even bring a picnic to eat and celebrate the day. The folks seen here would have needed to be extra careful so as not to dance off the stump. (Both, courtesy of Mark Sundquist.)

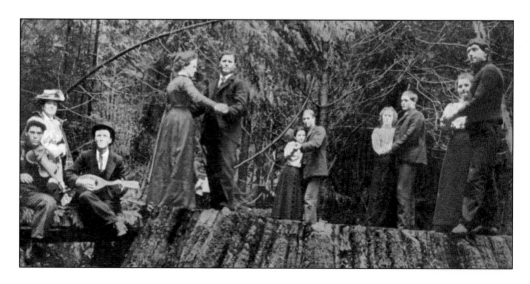

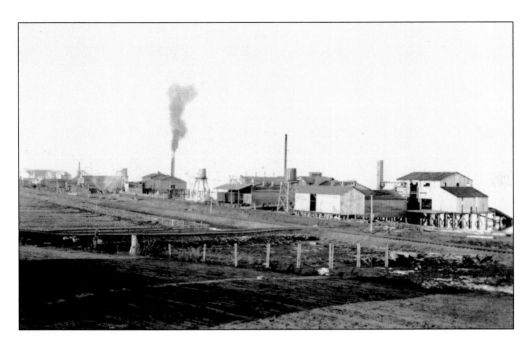

On the waterfront, 14 mills were established both north and south of what is now the ferry dock. According to a map, there were four mills north and ten mills south of the dock. Most of the mills produced shingles; the one farthest south was an excelsior mill. Most of the forest was dominated by western red cedar, western hemlock, and Douglas fir. George Brackett started the first mill in 1889. His mill, along with the rest, switched from lumber to shingles. Jobs were plentiful for several decades. Every mill eventually suffered a fire or other serious accident. The inside of a mill is shown below. The last one shut down in June 1951. (Both, courtesy of Edmonds Historical Museum.)

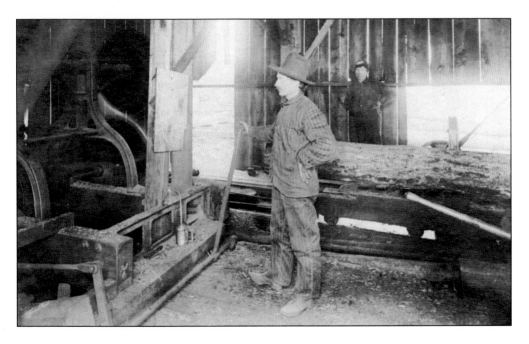

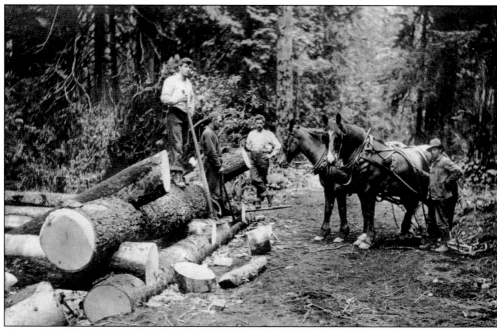

Above, laborers pose with the logs they have cut that day. No skidder is shown, but the apparatus used to connect the skidder can be seen behind the horses. These men look tired, but they are probably glad that they are working. Note how dense this forest is. The men have been able to create a trail for the horses and themselves leading back to Edmonds. In Edmonds, even on the main streets, the corduroy roads were made of logs. Logs kept the mud at bay and made it easier to skid them down the gently sloping hills to the mills. Below, three loggers rest at the base of a tree with some lady friends. (Both, courtesy of Edmonds Historical Museum.)

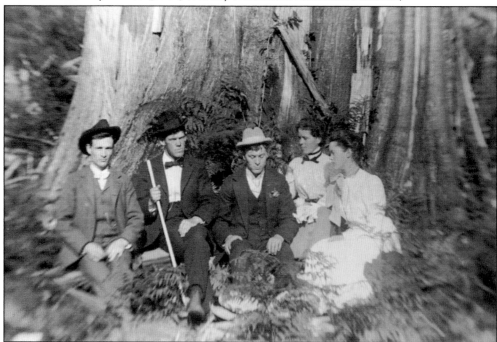

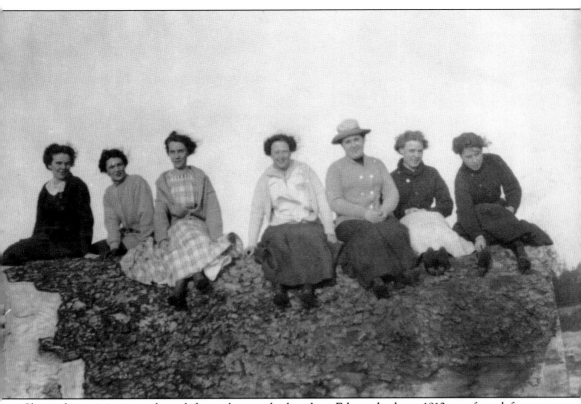

Shown here sitting on a huge leftover log on the beach at Edmonds about 1912 are, from left to right, Janette Bliss, Amy Mowat, Marguerite Chase, Erminie Van Ostrand, Annie Troll, Caroline Cogswell, and Frances Anderson. Some were teachers, like Anderson. They were also close friends, and several of them attended high school in Edmonds with Anderson. (Courtesy of Edmonds Historical Museum.)

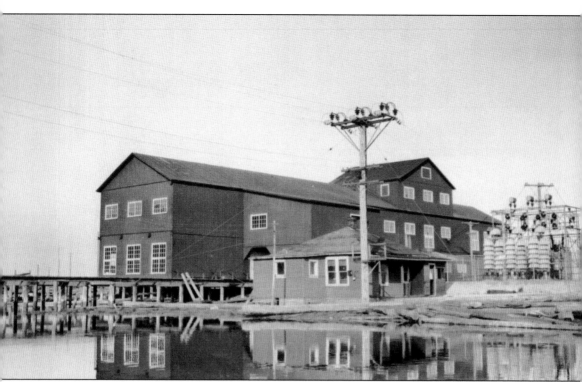

The log the girls sat on in the previous photograph may have been located in front of the Bach Lumber Company Mill, pictured here around 1920. The building was erected in 1909. In 1919, it was bought by La Verne, and it began producing sharkskins. In 1923, B.A. Strawbridge of Seattle bought the mill, using it to produce pulp. (Courtesy of Edmonds Historical Museum.)

Four

SCHOOLS, TEACHERS, AND STUDENTS

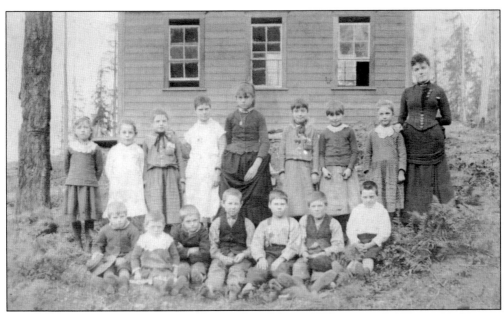

The building shown here is the first official Edmonds Grade School, located just north of George Street, between Third and Fourth Streets. In this 1887 photograph, the students are, from left to right, (seated) Oscar Deiner, Ralph McAlpine, Harry Deiner, George Brackett Jr., Frank E Deiner, Fred Fourtner, and Allan Smith; (standing) Maybell White, Fannie Brackett, Ethel Smith, Zetta Fourtner, Flora Deiner, Ruth Hyner, Annie Deiner, and Nellie Brackett. The teacher is unidentified. (Courtesy of Edmonds Historical Museum.)

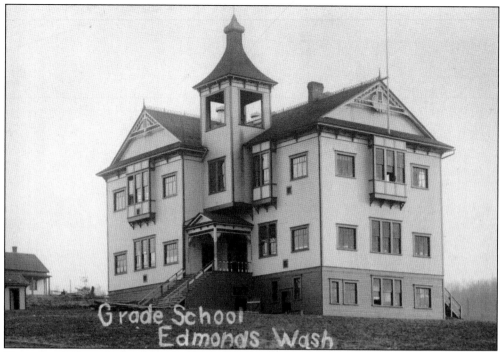

The second Edmonds Grade School is pictured here in 1912. The school was built in 1891 and operated until 1928. First through eighth grades were taught at the school. All of the photographs of teachers and students during these years were taken on the school's stairs. By the late 1920s, the school was getting so crowded that a new one needed to be built. (Courtesy of Edmonds Historical Museum.)

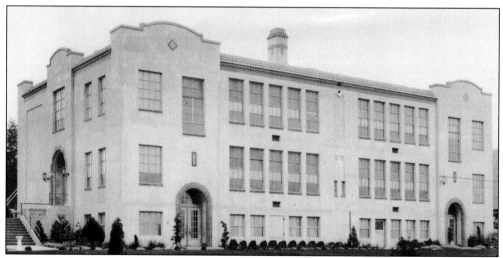

Seen here in 1930 is the third Edmonds Grade School. It was built in 1928 and used until the 1970s, when it became the Frances Anderson Recreational Center. This school served first through sixth grades. In 1948 or 1949, it had its first kindergarten classes. By then, more rooms were added to the building, where the arched doors are located. (Courtesy of Edmonds Historical Museum.)

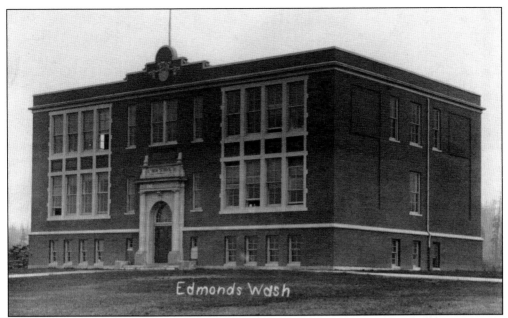

The first Edmonds High School was built in 1909. According to the photograph's accompanying description, three students graduated in its first class in May 1910. According to *Edmonds: The Gem of Puget Sound,* by Ray V. Cloud, those students were Mary Dorgan (daughter of principal W.H. Dorgan), Dunbar White, and Paul Bigelow. (Courtesy of Edmonds Historical Museum.)

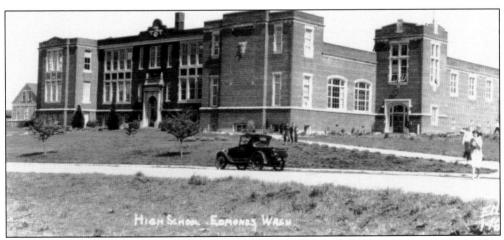

Additions to Edmonds High School were authorized in April 1920. The growing region had so many students that more room was needed to accommodate them. Students from Edmonds, Alderwood, Lynnwood, Meadowdale, and Woodway Park attended what was then the only high school in Edmonds School District No. 15. (Courtesy of Edmonds Historical Museum.)

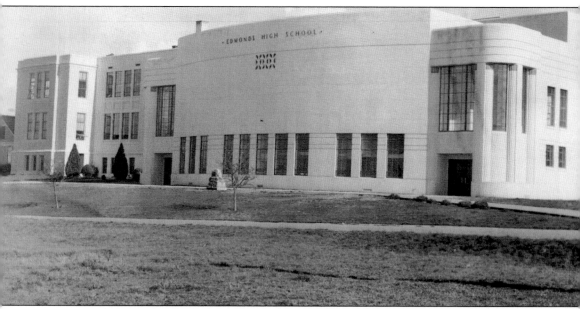

In 1938, Edmonds High School underwent another addition, including a curved Art Deco facade. Edmonds continued as the only high school until the late 1950s, when another, more modern building was erected on 212th Street, close to Highway 99. The old high school became Edmonds Junior High School in 1957. (Courtesy of Edmonds Historical Museum.)

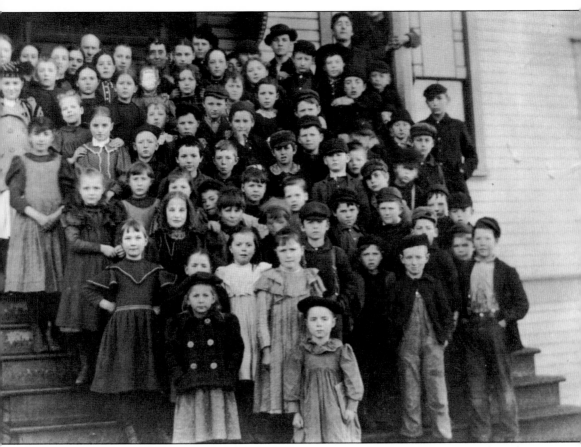

Students pose on the steps of Edmonds Grade School, on Main Street between Seventh and Eighth Avenues, in 1896. Only two children are identified here. Edith Brackett is at left in front, with five white buttons on her jacket. Kate Boshart is in the fourth row, far left, in a jumper dress. (Courtesy of Edmonds Historical Museum.)

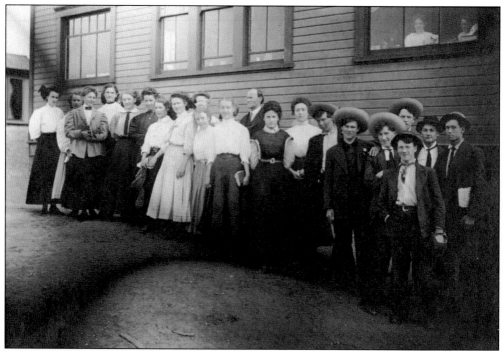

On May 10, 1909, the first Edmonds High School students and three teachers pose for a photograph. Included here are, from left to right, Ethel and Anna McKillican, Edith Brackett, Anna Holmes, Myrtie Rynearson, Frances Anderson, Vera Wasser, Ida Dorgan, Mrs. McNamara, Irma McGonagill, Anna Wilsted, Mr. Dorgan, Alma Jones, Miss Arnot, Herbert Campbell, Tom Dorgan, Dunbar White (who graduated in May 1910), Guy Holmes, Elias Cook, Walter Taylor, and Earl Sweet. (Courtesy of Edmonds Historical Museum.)

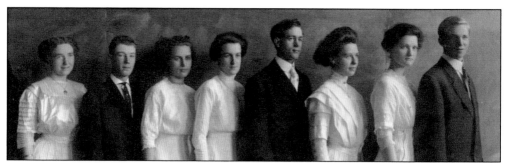

This is the Edmonds High School graduating class of 1911. They are, from left to right, Myrtie Rynearson (Otto), Elias Cook, Anna McKillican, Ethel McKillican, Earl Sweet, Frances Anderson, Anna Holmes, and Oscar Johnson. Otto later owned Myrtie Otto's Sewing Notions Store in the 1940s and 1950s. Cook was the son of Mayor W.H. Cook. Anderson became a teacher and principal at the Edmonds Grade School. The recreational center that used to be the grade school was named after her. (Courtesy of Edmonds Historical Museum.)

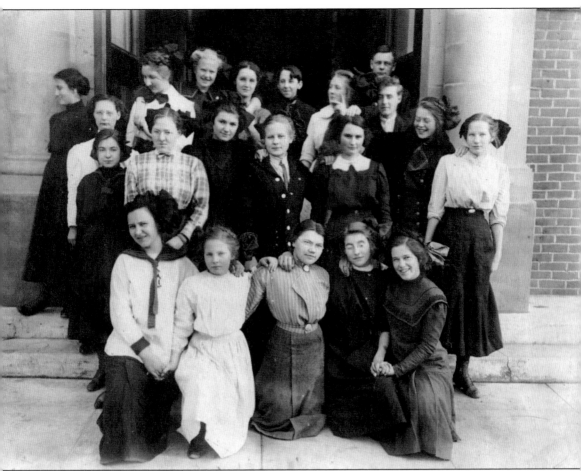

This is the Edmonds High School eighth-grade class in 1911. These students would graduate in 1915–1916. They are, from left to right, (first row) Ella Judy, Dorothy Johnson, Olga Johnson, Josine Erdevig, and Maude Hall; (second row) Edda Scalf, Virginia Rowe, Betsie Anderson, Addie Caspers, Hulda Medeen, and Cora Moore; (third row) Hal Bigelow, Lenore Pike, and Helen Johnson; (fourth row) Hazel Oakes, Mary Brackett, Fern Bradley, Daniel Laney, Vertrees Inman, Dally Kelley, and Russell Moorehouse. (Courtesy of Edmonds Historical Museum.)

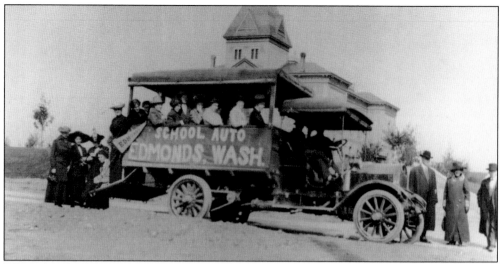

Edmonds School District No. 15 teachers ride in the school automobile to the Snohomish Institute in 1912. The building in the background is Snohomish High School. The automobile, supplied by the Yost Garage, was created by the owners and workers at the garage for this purpose. It was most likely also used as a school bus for students. (Courtesy of Edmonds Historical Museum.)

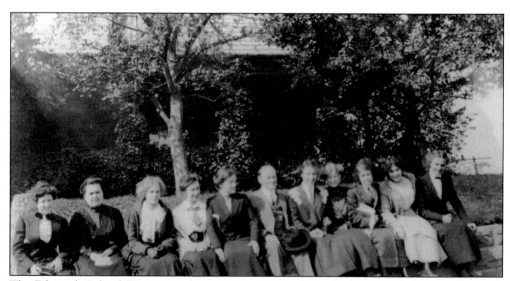

The Edmonds School District teachers sit on a stone wall at the Snohomish Institute in 1912. They are, from left to right, Erminie Van Ostrand, Annie Troll, Marguerite Chase, Jeannette Bliss, unidentified, Prof. W.H. Dorgan, Frances Anderson, Etta Farr, Blanche Brace, Caroline Murdock, and Caroline Cogswell. (Courtesy of Edmonds Historical Museum.)

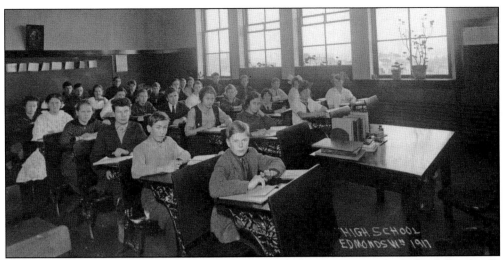

The seventh-grade students shown above in 1917 include, in no particular order, Lillie Astell, Meta Dickinson, Jimmie Otto, Stanley Heberlein, Glynn Schmidt, Hilding Anderson, Richard Erickson. Ellen Fourtner, Gertrude Anderson, Eleanor Sweet, Vera Wallace, Estelle Fowler, Louis Soukup, Henry Strid, Edward Bacon. Elaine Russell, Gladys Burbank, Max McLease, Mildred Anderson, Yerda Kaleen, Alice Peterson, Ray Dahlberg, Fay Chase; Last: Frank Flodin, Delbert Headley, Marion Chase, Hilda Lambe, Florance Peterson, and Betty Sandy. In the below photograph are members of the eighth grade. They are, in no particular order, Evert Hough, Ted Leyda, Edna Erdevig, Elain Hjorth, Nancy Hennesey, Florence Goodman, Charel Grace, Delight McConnell; Middle: Herman Brandiff, teacher, Elden Grace, William Lambe, Charlie Jackson, Chester Depew, unidentified, Douglas McClane, William Russell, Carl Modra, Ina Bevis, Edna Sorenson, Mary McGinnis, Esther Farmer, Dorothy Schmidt, Laura Waters, Edna Teuke, Cleo Seeley, Hazel Smith, and Bessie Oake; back: George Dahlberg, Victor Strid, Alice Preston, Tom Williams, Hazel Baker, and Jack Dawson. (Both, courtesy of Edmonds Historical Museum.)

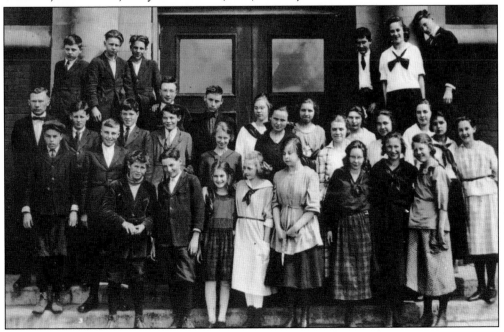

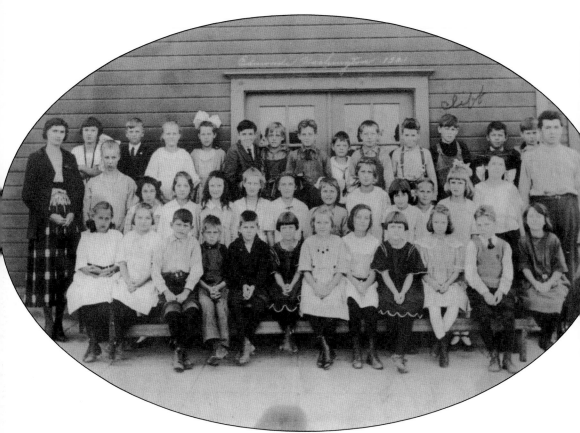

This photograph shows the original Edmonds Grade School class, with what appear to be two teachers. The group is posing in front of the grade-school building at Seventh Avenue and Main Street in 1921. Included here is one partially identified student, Cliff ?, third from the right in the back row. (Courtesy of Edmonds Historical Museum.)

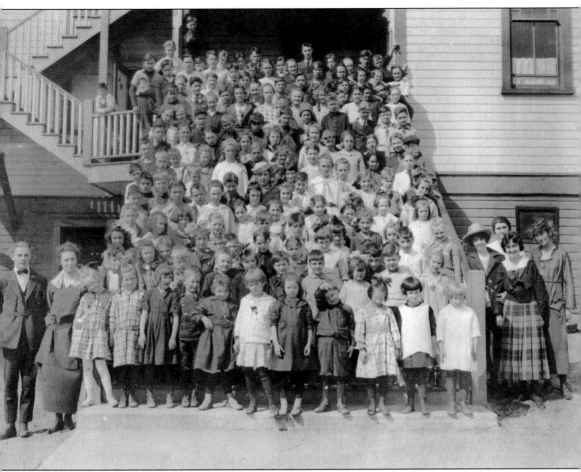

In 1924, the entire Edmonds Grade School, teachers and students, were photographed. The teachers in the front, at far left, are Emil Engler and Frances Anderson. The teachers on the far right are said to be, from right to left, Josine Erdevig, Olga Stone, Arlene Cusick, and Adrienne Caspers. Erdevig's full name after her marriage was Olga Josine Erdevig Stone. So, perhaps she is one of these teachers, and the other is unidentified. (Courtesy of Edmonds Historical Museum.)

This is a close-up of the photograph on the previous page, showing the teachers on the right side. The woman at far right is Olga Josine Erdevig Stone, who lived at the top of "Union Oil Hill." Arlene Cusick (second from left) and Adrienne Caspers (left) are also shown here. The fourth woman is unidentified. Caspers was part of the family for whom Caspers Street is named. (Courtesy of Edmonds Historical Museum.)

Members of the graduating class of 1924 are, from left to right, (first row) Esther Farmer, Delight McConnell, Helen McDonald, Lucile Moore, Dorothy Schmidt, Florance Goodman, June Quarles, Helen Harris, Lillian Mowat, Ruth Eisinger, Zelda Stogsdill, Bessie Oake, Mary McGinnes, and Edna Erdevig; (second row) Ina Bevis, Edna Fredell, Elden Grace, Wallace Ross, Gordon Ross, Wilfred Erickson, Chester Depew, unidentified, Douglas McClane, Paul Priebe, Ronald McDougall, Evert Hough, May Hill, and Irene Ernst. (Courtesy of Edmonds Historical Museum.)

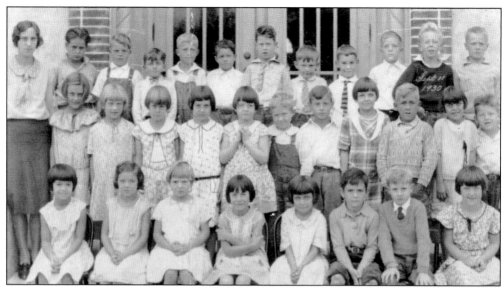

The 1930 second-grade class poses with teacher Lillian Christofferson. Shown here, in no particular order, are (first row) Donna Bell Hackett, Robert "Bob" Sorenson, Dorothy Daniel, and five unidentified students; (second row) Agnes Anderson, Yvonne Davis, Jack Tuson, Jerry Grover, Dorothy Davis, and Warren "Bud" Carpenter; (third row) Christofferson, Fred Jones, Bob Coomer, John Kelly, unidentified, Craig Milton, Jack Collins, Max Fisk, Vic Roe, Robert "Bob" Caspers, Leroy Miller, and unidentified. (Courtesy of Edmonds Historical Museum.)

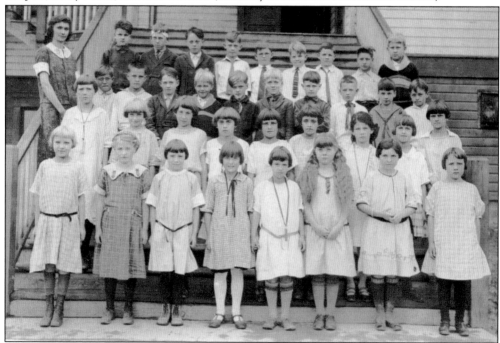

Edmonds Grade School's fourth grade is seen here in the 1924–1925 school year. The only identified student is Clint Gray, in the fourth row, second from left. In the 1950s, he was a crew member of the Edmonds Volunteer Fire Department. The teacher is Adrienne Caspers. (Courtesy of Edmonds Historical Museum.)

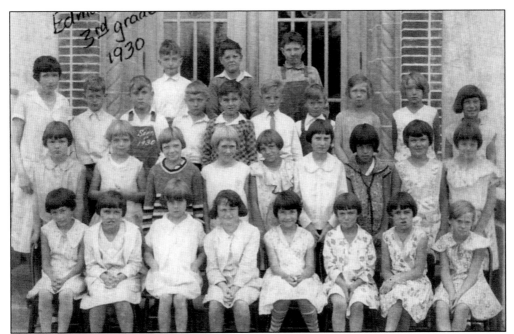

Edmonds Grade School third graders and their unidentified teacher pose in October 1930. Olyn Foard is in the third row, third from the left. He was one of Olga Josine Erdevig Stone's nephews, the son of her sister Harda Caroline Erdevig, who married Walter Louis Foard. (Courtesy of Erdevig/Roe descendents.)

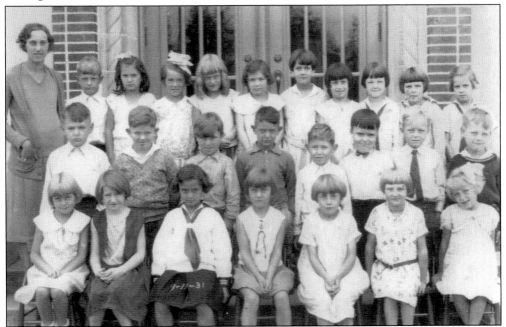

This Edmonds Grade School second-grade class poses on September 11, 1931. The teacher is unidentified. Carol Foard is the one student identified. She is in the third row, second from the right. She is Olyn Foard's next-youngest sister. Olyn was Harda Erdevig and Walter Louis Foard's one son. Harda was a sister of Olga Josine Erdevig Stone. (Courtesy of Erdevig/Roe descendents.)

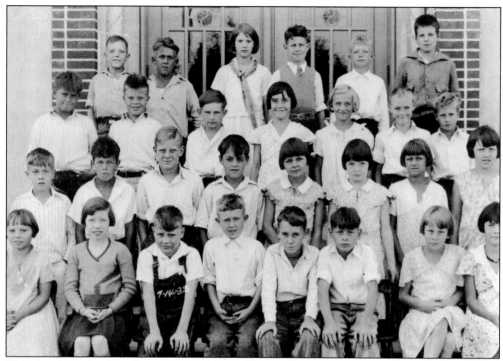

This fourth-grade class photograph, taken in 1932, includes, in no particular order, (first row) Vivian Womer, Jack Tuson, Vic Roe, Jerry Grover, and Agnes Anderson; (second row) William "Bill" Eldridge, H. Craig Milton, Joe Garnett, Dorothy Davis, Yvonne Davis, and Dorothy Daniels; (third row) Bill Coomer, Max Fisk, La Verne De Voy, Alice Hawkings, Eugene McMaster, and Bob Sorenson; (fourth row) Bob Caspers, Warren "Bud" Carpenter, and Jack Colley. (Courtesy of Edmonds Historical Museum.)

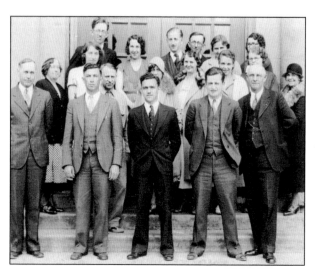

The Edmonds High School faculty gathers in 1932. They are, from left to right, (first row) Henry H. Hoffland, Warren Bieber, Mr. Leyda, Paul McGibbon, and A.C. Kellogg; (second row) Agnes Carlson, Inga Stevens, George Hatch, Marjory Murphy, Hallie Anderson, Virginia Friend, Luella Jones, and Grace Bliss; (third row) Duncan Jakobson, Ruth McConihe, Henry J. Novak, Wilbur Goble, Emma Meldrum, and Catheryn Evans. McGibbon was later the mayor of Edmonds between 1949 and 1955. (Courtesy of Edmonds Historical Museum.)

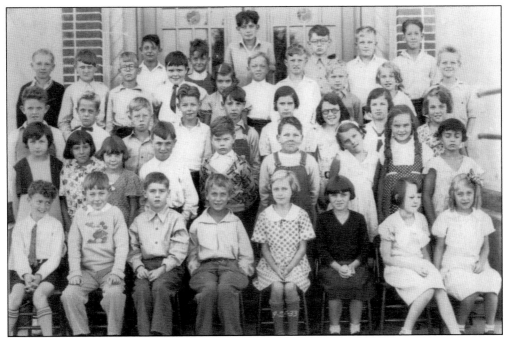

On September 2, 1933, the fourth grade of Edmonds Grade School poses for a photograph. Carol Foard is in the second row, third from right. She was younger sister of Olyn Foard and a relative of Mrs. Stone, the author's fourth-grade teacher. This class's teacher, not pictured, is unidentified. (Courtesy of Erdevig/Roe descendents.)

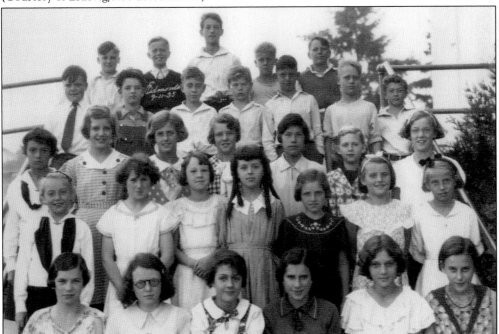

Edmonds Grade School's sixth-grade class is seen here on September 11, 1935. Carol Foard is in the second row, second from the right. The teacher is not shown and is not identified. (Courtesy of Erdevig/Roe descendents.)

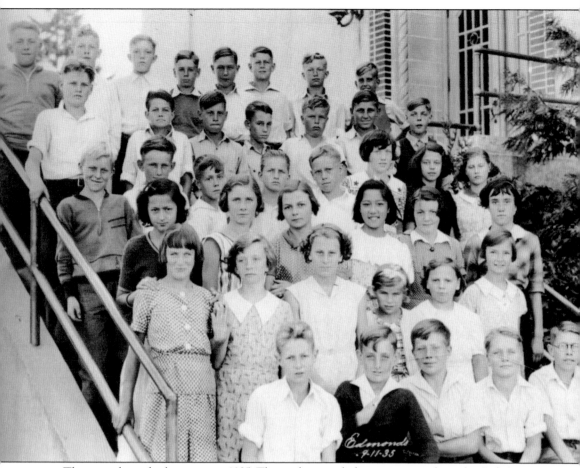

The seventh-grade class poses in 1935. The students include, in no particular order, Bob Sorenson, John Kelly, Richard Taylor, Walter Goulet, Eugene McMaster, Agnes Anderson, Margaret Date, Vivian Womer, Eloise Mitchell, Adaline Osborn, Mary Ann Campbell, Dorothy Daniel, Teiko Mafune, Yvonne Davis, LaVerne DeVoy. Max Fisk, Bill Eldridge, Ted Cooper, Jack Martinson, Craig Milton, Jerry Grover, Vic Roe, Bob Coomer, Stan Kaufman, Lester Munn, Bud Carpenter, Bob Caspers, Phil Roe, Jack Colley, and "Eric" Carlson. (Courtesy of Edmonds Historical Museum.)

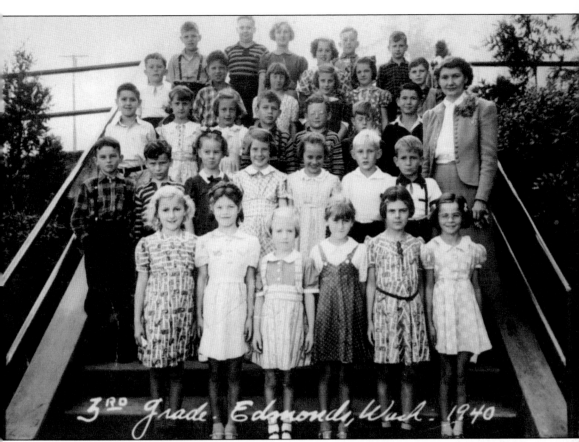

Seen here is the 1940 third-grade class picture. Shown are, from left to right, (first row) Jean Jakobson, Merle Flick, unidentified, Shirley Daniel, Beverly Bienz, and Barbara Savage; (second row) Gene Hoffer, Ross Waggoner, unidentified, Nina Armes, unidentified, Jack Jakobson, and Howard Leyda; (third row) unidentified, Sally Davis, Alice Hinkleman, Douglas Larson, Keith Jerome, Richard Hildebrand, and teacher Adrienne Caspers; (fourth row) Bob Ruth, John Bieber, LaVonne Deiner, two unidentified, and Don Baily; (fifth row) Don Larson, Trent Tilquist, two unidentified, Glen Richards, and John Meyer. (Courtesy of Edmonds Historical Museum.)

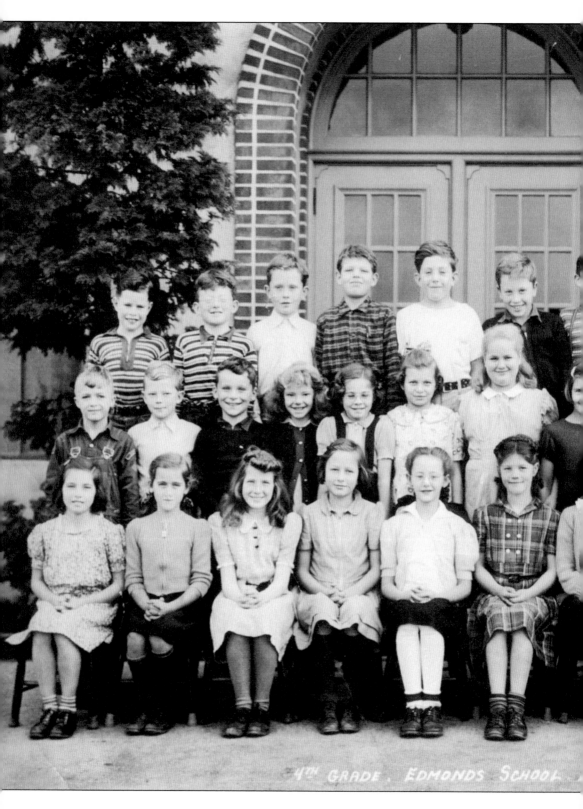

4TH GRADE, EDMONDS SCHOOL

The fourth-grade class of Gwendolyn Shakespeare is seen here in 1941. The students are, from left to right, (first row) Bonnie Smith, Shirley Daniel, Nina Armes, Alice Hinkleman, Sally Davis, Merle Flick, LaVonne Deiner, unidentified, and Gean Jackobson; in no particular order, (second row) Floyd Nillis, Bob Lane, Ross Waggoner, Laura Lee Ewing, Rosanne Garnett, Beverly Bienz, Jack Jackobsen, Gene Hoffer, and Pat Howlett; (third row) Paul Glantz, Keith Jerome, Bob Ruth, Don Larson, Glen Richards, Richard Hildebrand, John Beiber, John Meyer, and Eddie Fink. (Courtesy of Edmonds Historical Museum.)

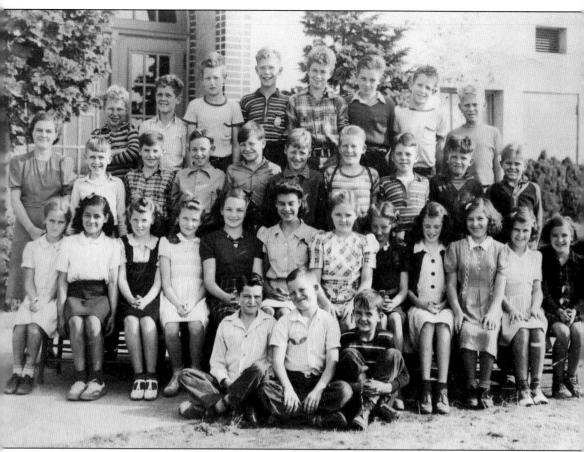

Seen here are fourth and fifth grades in October 1942. Students are, from left to right, (first row) Charlie Arrowood, Eddie Rommel, and Bill Bradford; in no particular order, (second row) Shirley Daniel, Nina Armes, Ruth Ann Eide, Sally Davis, LaVonne Deiner, Dorothy Bryan, Beverly Bienz, and Jane Peters; from left to right, (third row) Don Baily, Don Benn, Chester Duke, Leo Mangan, Alfred Galbraith, Don Eney, and John Bieber; (fourth row) Alan Smith, Dean Jackson, Jack Ellison, Jack Edwards, Kenny Ryland, Bill Ellison, and Gene Tilson. The teacher is Nettie Preston. (Courtesy of Edmonds Historical Museum.)

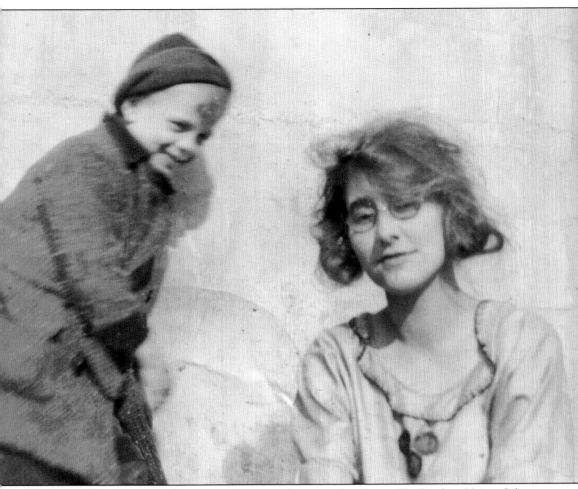

Olga Josine Erdevig poses with a boy, perhaps a nephew, near her home. She lived on Union Oil Hill before it became part of the city of Woodway. At some point, she married Charles Hugh Stone. She lived on that property for nearly her entire life. She may have gone to the Yukon goldfields during the Alaska Yukon Gold Rush. She taught school there, then met and married Charles. Olga passed away in 1990, and Charles died in 1995. (Courtesy of Erdevig/Roe descendents.)

In this photograph, Jo Erdevig is in front of her home, getting ready for her high school or college graduation. She began teaching either right after graduating from high school or after attending a normal school. She was teaching in 1924 at the Edmonds Grade School and taught until at least 1960. (Courtesy of Erdevig/Roe descendents.)

Joyce Koerner, the daughter of George C. and Leona Nickerson Koerner, was born on September 15, 1911. The photograph at right shows her in her pram with her mother. Koerner grew up mostly in Edmonds, taught in Illinois for 11 years, then went to Washington. Once there, she taught on the Olympic Peninsula for eight years and then in Edmonds for 24 years. She traveled extensively in Europe, too. Koerner wrote *The Historical Study of Edmonds*, a fourth-grade textbook used until about 20 years ago by the grade school. She is seen below at about age seven or eight, perhaps ready for school. She died on January 24, 1998, at the age of 86. A memorial service was held in the chapel at Beck's Funeral Home in Edmonds. (Both, courtesy of Edmonds Historical Museum.)

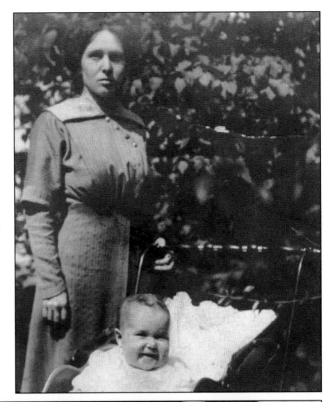

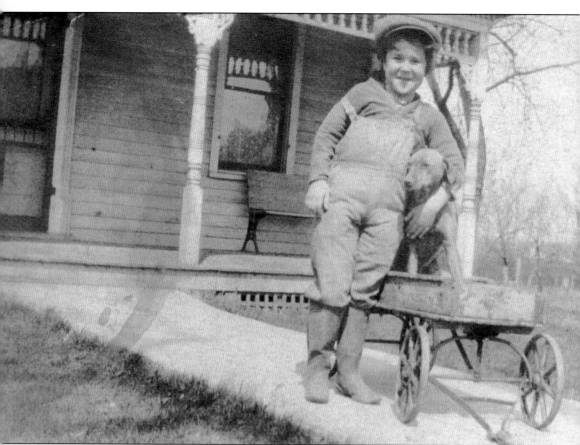

Joyce Koerner appears to be a tomboy in this photograph, wearing play clothes and boots for the muddy ground. She is giving her dog a ride in her wagon. The textbook and test questions she wrote years later helped students think more clearly and learn about the history of Edmonds. (Courtesy of Edmonds Historical Museum.)

Five

INDIAN SCHOOL AND EDMONDS SCHOOLS

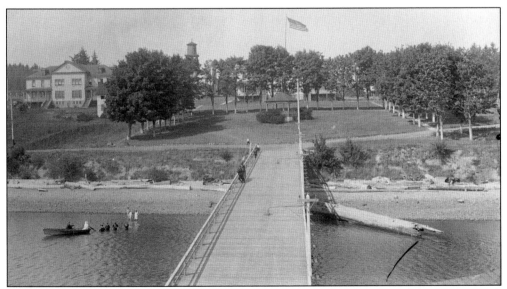

This waterfront photograph was taken from the Puget Sound docks at the Tulalip Reservation's boarding school. This is where the children would arrive at the beginning of the school year and leave at the end of it. The children were discouraged from using their native languages, even at home. (Courtesy of Everett Public Library, Northwest Room.)

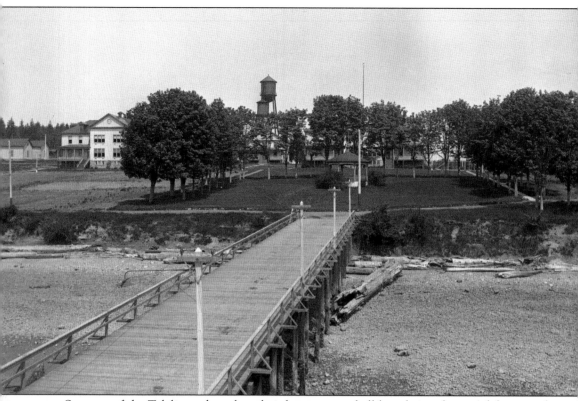

So many of the Tulalip students lost their language, and all lost their culture. Adults, now the elders of the tribes, who attended this school are still filled with fear about relearning their own cultures and languages. They are being taught by their own children and grandchildren now. Some children lost their very lives to the brutality of the adults at the school. (Courtesy of Everett Public Library, Northwest Room.)

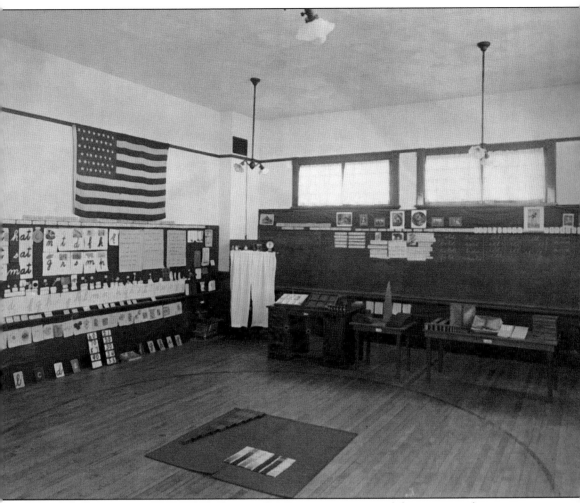

The Tulalip Boarding School Montessori classroom was organized for optimum learning. Everything was assigned to special places and organized at the children's eye level. Discipline for the children was often brutal and shaming. The school's overriding idea was to get rid of the culture of the Indian children so that they could be "civilized." (Courtesy of Everett Public Library, Northwest Room.)

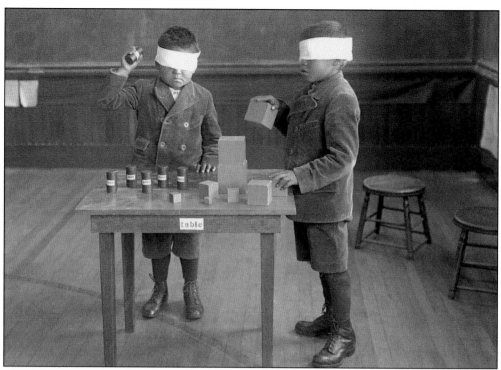

These demonstrations of the Montessori method were arranged for a presentation at the Panama Pacific International Exposition in 1915. Children often worked together in pairs, trios, or small groups, learning together. They explored specific items set out for them to use. Most of the children, especially the youngest, had never heard English, yet were forced to speak it or get punished. In this way, they completely forgot their native languages and their own rich cultures. Punishment included beatings, deprivation of food and beverages, and shaming. The Indian child was considered inferior to children of the dominant culture. The cultural norms of the Native Americans were considered to be evil by political and educational leaders. (Both, courtesy of Everett Public Library, Northwest Room.)

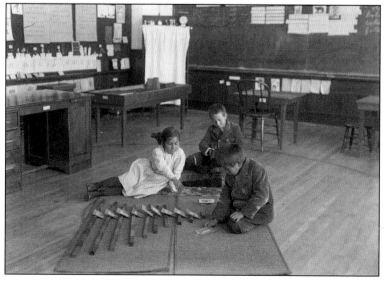

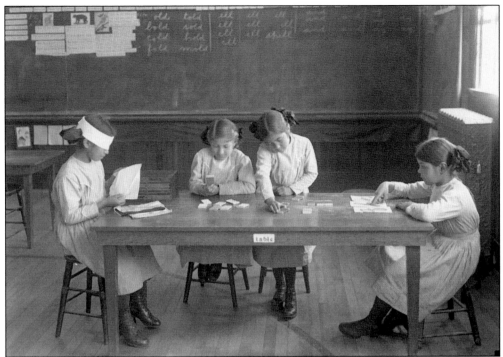

As can be seen in these two photographs, Indian children almost always had to wear a "uniform" of sorts. The boys had to wear knickers, a jacket, and a shirt, plus boots and socks. The girls wore a dress, long stockings, and boots. Public schools did not require uniforms, but Catholic schools did. The Indian children who went to the Tulalip Reservation's boarding school very seldom had any reason to smile about anything, and most were extremely unhappy. However, they had no choice in the matter of how to spend their school days. They came from many different tribes in the Puget Sound region. (Both, courtesy of Everett Public Library, Northwest Room.)

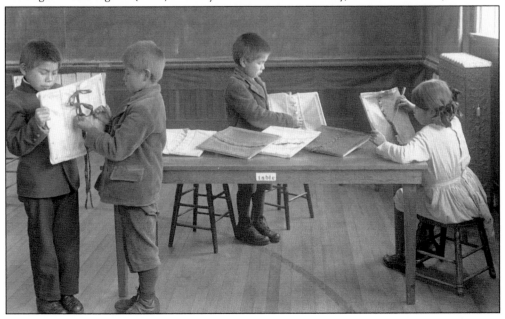

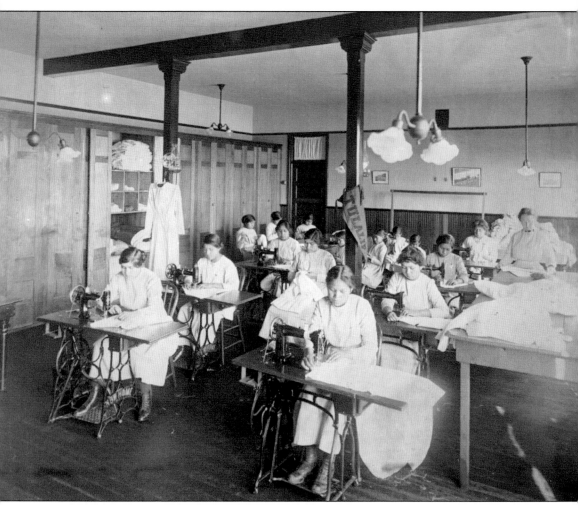

The sewing class was for girls only. They learned how to sew on the treadle machines, first learning how to thread the needles and bobbins and then gradually become proficient enough to create all the clothing the children wore at the school. (Courtesy of Everett Public Library, Northwest Room.)

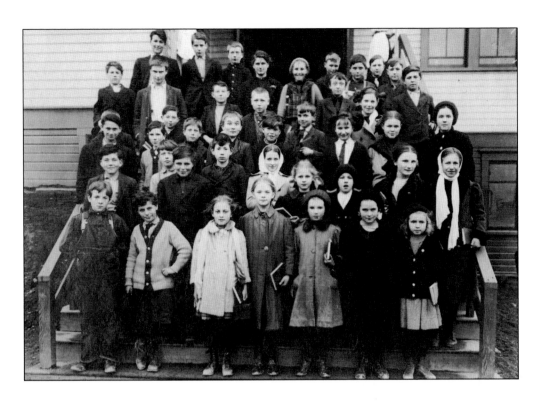

The above photograph shows the fifth-grade class of Phoebe Reynolds and Sarah Armstrong in 1912. The students include, in no particular order, Dewey Leyda, John Stone, Rebecca Erdevig, Abbie Otto, Brilliant Keeton, Edris Bigelow, Argell Lemley, Anita Leyda, Leila Martin, Winona Bennett, Beulah Clark, Betty Kahlstrom, Harry Lown, Lena Kuehl, Paul Rule, Harold Janeway, Bert Hansen, Neva Arp, Frank Lemley, Allan Erickson, Luella Stone, Mabel Doty, Frank Parker, George Jones, Carol Woodfield, and Harold Bailet. The below photograph, taken in 1914, shows eighth graders. They are, from left to right, (first row) Lena Kuehl, Lula Schmidt, Helen Wagoner, Edris Bigelow, Harold Janeway, Ross Grant, Emery Leyda, and Fred Heberlein; (second row) Allan Erickson, Harry Lown, Ethel Dinkle, Mabel Doty, Bessie Bell, Frank Parker, and Clair Britton; (third row) Leila Martin, Neva Arp, Marie Moses, Abbie Otto, Pearl Otto, Iola Schmidt, and George Jones. (Both, courtesy of Edmonds Historical Museum.)

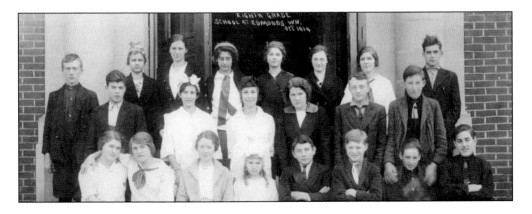

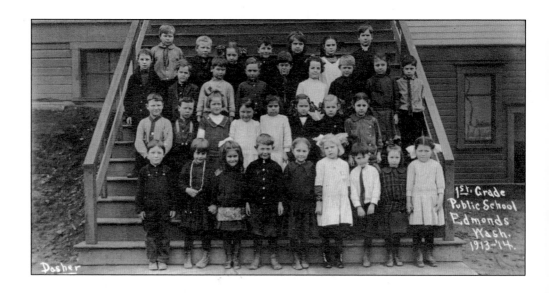

The above photograph shows a first-grade class in 1913. Among the children are, in no particular order, (first row) Don McReynolds, Edna Erdevig, Lyle Bettinger, Mae Carpenter, Eleanor Sill, Noel Smith, Irma Yost, and Anna Anderson; (second row) Edna Bacon (third from left), Ruby Carpenter (far right); (third row) Austen Holmes, Jimmie Carey, Janet Taylor, Torgne Bjornson, Signe Carlson, and Guy Anderson; (fourth row) Gladys Yost (third from left), Glen Miller (fourth from left), and Dot Clark (second from right). The below photograph is of Miss Leo's second grade in 1914. Shown here are, in no particular order, (first row) Janet Taylor, Ida Headly, Irma Yost, Mac Carpenter, unidentified, Anna Anderson, Stella ?, Noel Smith, Don McReynolds, and Cecil Henry; (second row) Guy Anderson, Jimmy Carter, unidentified, Eleanor Sill, Mary Lamberton, Signe Carlson, Gladys Yost, Edna Bacon, unidentified, and Jimmy Lamberton; (third row) unidentified, Glen Miller, unidentified, Lilian Mowat, unidentified, Dot Clark, Austen Holmes, unidentified, and Albert Bjorenson. (Courtesy of Edmonds Historical Museum.)

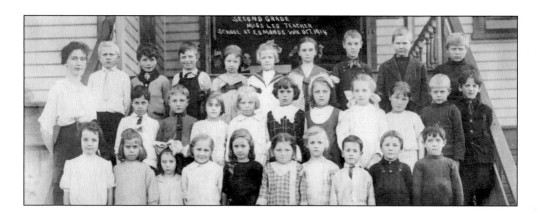

The barn on the Tulalip Reservation was one of the places where the boys did their chores. Boys also did nearly all the other outdoor work, including gardening and animal husbandry to provide food for everyone in the school. They chopped firewood to supply the buildings with heat in the winter and fuel all year for the stoves. They also hauled water wherever it was needed. (Courtesy of Everett Public Library, Northwest Room.)

Indian children learned to play musical instruments, perhaps similarly to the ways children elsewhere were instructed. There may have been singing lessons, too. It appears that Indian children may have been separated into girls and boys programs. Children at the Tulalip School were encouraged to play sports, probably baseball, basketball, and football. The genders may have been separated on sports teams, too. Members of the boys' band (above) played various brass instruments, clarinets, and percussion. Instruments for the girls' orchestra (below) include guitars, mandolins, and bass violins. (Both, courtesy of Everett Public Library, Northwest Room.)

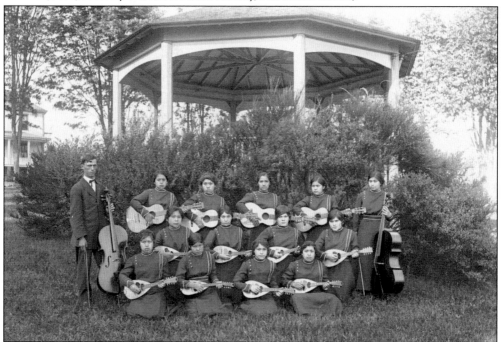

Six

FERRIES, TRAINS, AUTOMOBILES, AND BUSES

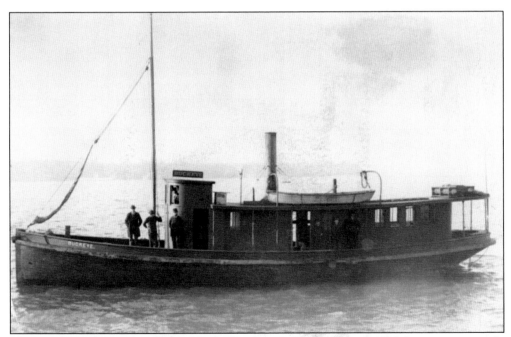

The Puget Sound steamship *Buckeye* was built in Seattle, Washington, in 1890. It was approximately 62 feet, or 18.9 meters, long and was 19.8 feet abeam. Its gross tonnage was 87 tons, but its registered tonnage was 52 tons. The *Buckeye* (registration no. 3474) lasted until 1930 and was apparently abandoned. (Courtesy of Edmonds Historical Museum.)

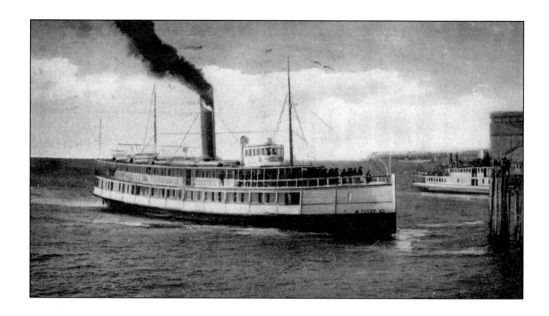

The *Flyer*, built around 1891, was used as an express passenger steamship on Puget Sound. One of the ferries used on the Seattle-Edmonds-Everett run, she was the fastest steamship, running at an average of 18.5 miles per hour, but capable of much higher speeds. The *Flyer* was 170 feet long, 21 feet wide, and 15 feet deep. In 1906, she converted to oil fuel. In 1908, it was calculated that she had traveled the equivalent of 61 around-the-world trips and had carried over 3 million passengers. In service 344 days a year, the *Flyer* was considered one of the most reliable vessels. With oil fuel, she could make an entire run in one hour, including the 12 minutes at the Edmonds Dock. (Both, courtesy of Mark Sundquist.)

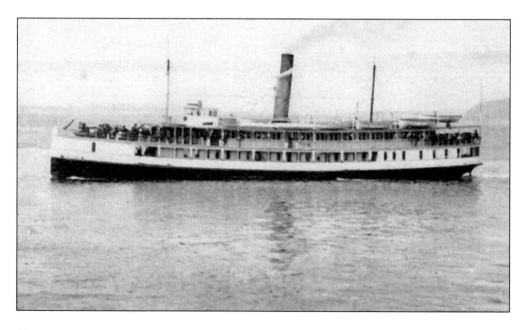

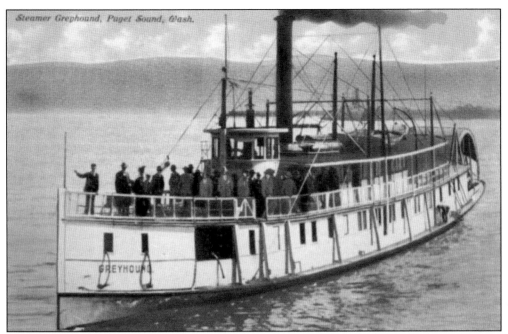

The *Greyhound* was one of several stern-wheelers plying the route between Everett and Seattle at the beginning of the 20th century. A sailing notice offered three round-trips daily except on Sundays. The fare from Edmonds was listed on the schedule as 50¢ one way and 75¢ round-trip. Meals were offered aboard for 25¢. (Courtesy of Edmonds Historical Museum.)

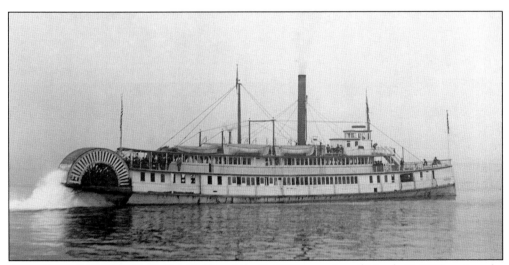

According to an article in the *Seattle Times' Pacific NW* magazine of March 17, 2003, written by Paul Dorpat, the *Telegraph* was built in 1903 in Everett for the Seattle-Everett run. It was sold to the Puget Sound Navigation Company in early 1912. Only a few weeks later, it crashed into the Colman Dock in Seattle. The ship and the clock tower at the dock sank into the water. The *Telegraph* was raised and repaired, as was the Colman Dock's clock tower. The *Telegraph* continued to be a viable steamer for several more years. (Courtesy of Mark Sundquist.)

FAST TIME

ON THE

Seattle, Everett and Edmonds
ROUTE

STEAMER

CITY OF EVERETT

THREE ROUND TRIPS DAILY

WEEK-DAY TIME CARD
Leave SEATTLE...7.00 A. M., 12 NOON, 5.00 P. M.
Leave EVERETT...........9.15 A. M., 2.15, 7.15 P. M.

SUNDAY TIME CARD
Leave SEATTLE...7.30 A. M., 12 NOON, 5.00 P. M.
Leave EVERETT...........9.45 A. M., 2.15, 7.15 P. M.

REDUCED EXCURSION RATES ON SUNDAYS
ROUND TRIP, 75 CENTS

MEALS SERVED

SEATTLE LANDING, COLMAN DOCK
Sunset Phone, Main 4084. Independent Phone, 1294

EVERETT LANDING, CITY DOCK
Main 122 Phones Main 813

This schedule indicates that the steamship *City of Everett* left Seattle every weekday at 7:00 a.m., noon, and 5:00 p.m., and left Everett at 9:15 a.m., 2:15 p.m., and 7:15 p.m. This schedule shows the one-way and round-trip rates, including the fares for connections to outbound points from both Seattle and Everett. The exact times that the steamer arrived and left Edmonds is not known, but it can be surmised that it was about one hour after its departure from Everett or Seattle, because Edmonds is about halfway between those cities. This schedule, only about two inches wide and four inches tall, was printed on very sturdy cardstock so that it would last. (Both, courtesy of Mark Sundquist.)

CONNECTIONS AT EVERETT

With Interurban for Snohomish Each Trip.
FARE
Seattle to Snohomish...........Single, $1.00
Seattle to Snohomish, Round Trip, 1.40

With Steamer Camano for Whidby Island Points.
Leaves Everett Daily, Except Sunday, at 3 p. m.

With Monte Cristo Railway for Monte Cristo and Way Stations.

CONNECTIONS AT SEATTLE

With Steamer Flyer for Tacoma

With Port Orchard Route for U. S. Navy-yard and Way Ports.

With Steamers for Vancouver, Victoria, Olympia and Bellingham.

With Pacific Coast Co. Steamers for San Francisco.

With Northern Pacific Railroad for Portland and East.

The Mosquito Fleet vessel *City of Everett* is seen docked at Edmonds around 1905. This boat was initially named *Liberty*, then was known as *Ballard*, and lastly *City of Everett*. It was built in Everett in 1890 as a propeller-driven passenger vessel, but it later became a ferry, running three times daily on the Seattle-Edmonds-Everett route. (Courtesy of Edmonds Historical Museum.)

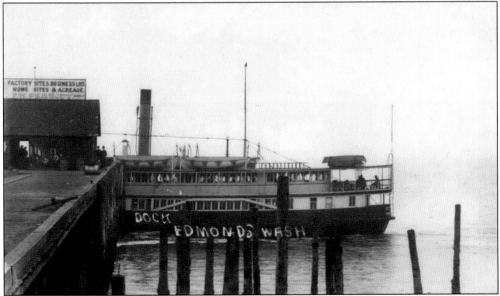

The *City of Everett* is docked in Edmonds in 1909. Beginning at the turn of the century, the *City of Everett* made three round-trips daily between Seattle, Edmonds, and Everett. She was the only means of transportation between Seattle and Edmonds, in particular. This ship went through a number of changes before she finally sank in Lake Union in 1967. (Courtesy of Edmonds Historical Museum.)

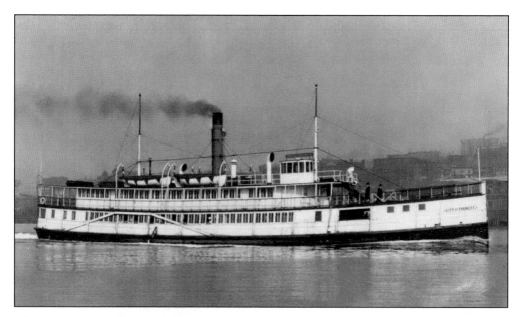

The *City of Everett* is shown above in Puget Sound. What a majestic view of this ship! Many people on the shore watching it ply the waters would feel excited, anticipating their chance to one day go on a round-trip excursion on the ship. Below, passengers board the *City of Everett* with their luggage in the 1920s. The Edmonds Dock must have been a bustling place, crowded with those wishing to head north to Everett or south to Seattle. Meals were served on the trips and cost only 25¢. On Sundays, there were reduced excursion rates, especially on round-trip fares. Best of all, one could get on a steamer or a train and go from Everett or Seattle to other points. (Both, courtesy of Edmonds Historical Museum.)

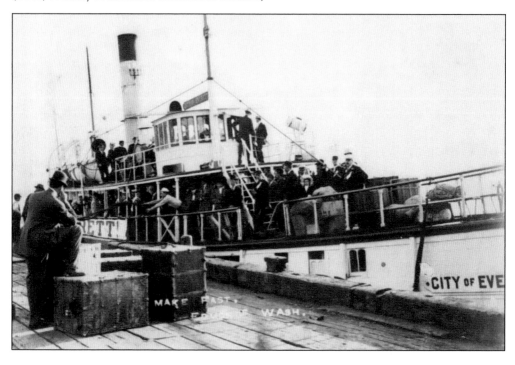

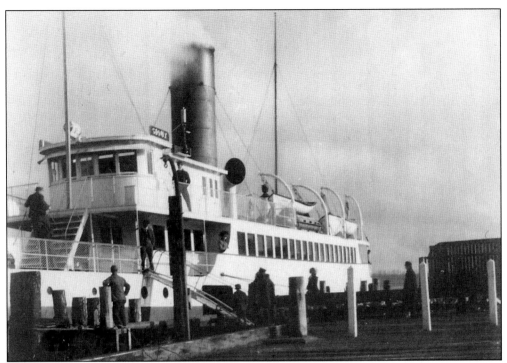

The *Sioux* (above) was completed in 1911 in Seattle. It ran from about 1912 to 1924 on Puget Sound and the Straits of Juan de Fuca, where the San Juan Islands are located. It was reconstructed to be an automobile ferry and renamed the *Olympic* (below), operating on the Seattle-Edmonds-Everett route until 1941. On August 16, 1912, the *Sioux* was in an accident at the Everett harbor. The engine-room assistant, an oiler, was left in charge of the telegraph. When the captain telegraphed the oiler to stop the vessel, the instructions were misunderstood, and the *Sioux* rammed into several other steamers. No one died, but, from then on, the Puget Sound Navigation Company switched to metal-hulled boats instead of ones with wooden hulls. (Above, courtesy of Mark Sundquist; below, courtesy of Edmonds Historical Museum.)

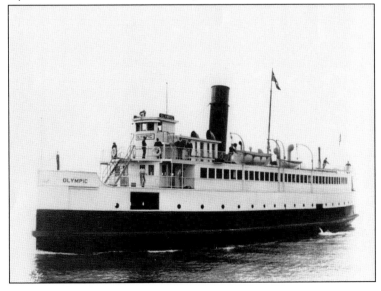

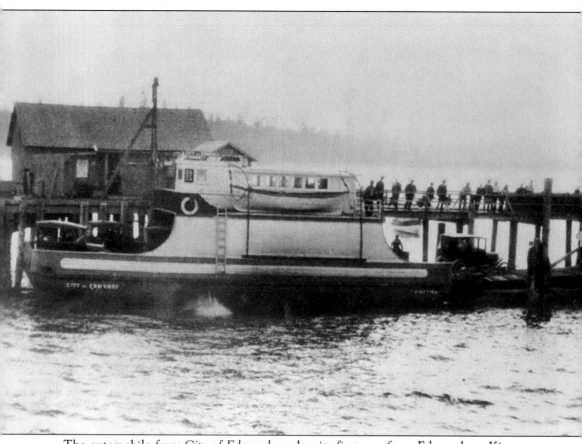

The automobile ferry *City of Edmonds* makes its first run from Edmonds to Kingston on Sunday morning, May 20, 1923, inaugurating a new route across Puget Sound. According to the *Edmonds Tribune-Review* of May 11, 1923, when regular service began, the ferry was "exceptionally well patronized" by both walk-on passengers and automobiles. (Courtesy of Edmonds Historical Museum.)

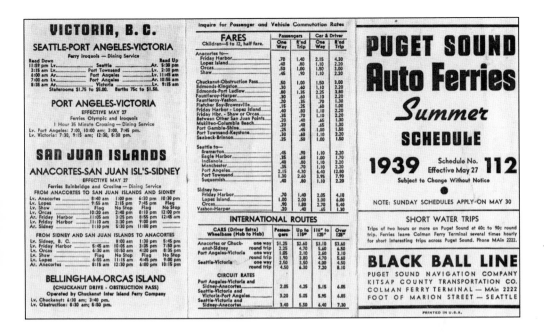

This schedule for the Puget Sound Navigation Company's Black Ball Line is for the summer of 1939. Included are all the ferries that plied Puget Sound, the times they departed and arrived, the places they went, and the fares for one-way and round-trip excursions, including weekdays, weekends, and holidays. As can be seen, the fares between Edmonds and Kingston were 30¢ one way and 60¢ round-trip. There was also a schedule and fares from Edmonds to Port Ludlow. Every imaginable route was covered, including international runs between cities in Washington State and British Columbia in Canada. The schedules used by the State of Washington for ferries these days are very similar to the schedule shown here. (Both, courtesy of Mark Sundquist.)

OLYMPIC PENINSULA HOOD CANAL

Seattle - Bremerton
Ferries Kalakala and Chippewa
55 Minute Crossing
Dining Service
Subject to Change June 16

Lv. Seattle	Lv. Bremerton
*6:30 am	*6:30 am
7:40	7:40
8:50	8:50
10:00	10:00
11:10	11:10
12:20 pm	12:20 pm
1:30	1:30
2:40	2:35
3:40	4:00
5:15	5:05
7:40	6:30
10:00	8:50
*12:20 am	11:10

*1:00 am on Sat. Night (Sunday morning)
*Except Sunday.

Seattle - Manchester
Ferry Rosario
55 Minute Crossing
Dining Service
Subject to Change June 16

Lv. Seattle	Lv. Manchester
8:00 am	6:50 am
10:15	9:00
12:30 pm	11:30
3:15	1:30 pm
5:00	3:00

Seabeck - Brinnon
Seabeck-Brinnon Ferry, Inc.
30 Minute Crossing

Lv. Seabeck	Lv. Brinnon
8:05 am	8:45 am
9:25	10:05
10:50	11:35
12:45 pm	1:25 pm
2:05	2:50
4:10	4:50
5:30	6:15
7:00	7:45

FAUNTLEROY - VASHON - HARPER
Ferry Chetzemoka — Dining Service
EFFECTIVE JUNE 1

Lv. Fauntleroy	Lv. Vashon	Lv. Harper
6:50 am	6:25 am	6:00 am
9:00	8:00	7:35
10:30	10:00	9:45
12:00	11:00	11:15
1:30 pm	1:00 pm	12:45 pm
3:00	2:30	2:15
4:30	3:45	3:45
6:00	5:30	5:15
*7:30	7:00	6:45
9:00	8:30	7:15
10:00	9:30	8:15
	11:30	11:15

*Vashon only.

NORTHERN OLYMPIC PENINSULA

Edmonds - Port Ludlow
Ferries Elwha and Quillayute
1 Hour 20 Minute Crossing
Dining Service

Lv. Edmonds	Lv. Port Ludlow
*6:15 am	
8:30 am	7:30 am
10:30	10:00
12:30 pm	12:30 pm
3:45	2:15
6:45	5:15
*9:30	8:15

SUNDAY ONLY
| 10:30 | 11:15 |

FOR YOUR CONVENIENCE
The return portion of round trip tickets and all commutation tickets of the Ballard-Ludlow Ferry Co. will be honored on the Edmonds-Port Ludlow route.

*9:45 pm Sundays.

Edmonds-Kingston
Ferries Elwha and Quillayute
25 Minute Crossing
Dining Service

Lv. Edmonds	Lv. Kingston
*6:15 am	*6:45 am
7:20	7:50
9:15	9:45
11:30	12:00
2:15 pm	3:30 pm
4:15	5:15
6:00	6:45
7:30	8:15

SUNDAY ONLY
| 9:00 | 9:45 |

*Except Sunday.

Seattle - Indianola - Suquamish
Ferry Kehloken
Dining Service
Subject to Change June 16

Lv. Seattle	Indianola	Suquamish
8:00 am	6:35 am	6:25 am
11:00	9:25	9:15
1:45 pm	12:05 pm	12:25 pm
*5:20	3:55	3:45
*8:00	*6:25	*6:45

SATURDAY AND SUNDAY
| 9:00 pm | | 9:15 pm |

*One hour later on Saturdays.

Port Gamble - Shine
Olympic Navigation Co.
10 Minute Crossing

Lv. Port Gamble	Lv. Shine
7:00 am	7:15 am
8:00	8:15
9:00	9:15
10:00	10:15
11:00	11:15
12:00	12:15 pm
1:00 pm	1:15
2:00	2:15
3:00	3:15
4:00	4:15
5:00	5:15
6:00	6:15
7:00	7:15
8:00	8:15

BAINBRIDGE ISLAND

Seattle-Eagle Harbor
Ferry Klahanie
Dining Service
EFFECTIVE JUNE 1

Lv. Seattle	Lv. Winslow	Lv. Eagledale
6:45 am	6:00 am	5:50 am
8:30	6:55	6:50
*9:00	7:35	7:40
10:15	9:15	9:20
*11:00	*10:05	*10:00
12:00	11:00	11:05
12:45	11:50	12:50
*2:30	*1:20	*1:15
3:30	2:30	2:35
*4:30	*3:35	*3:30
5:30	4:20	4:25
*6:30	*5:35	*5:30
7:15	6:15	6:20
9:30	8:00	8:05
11:30	10:20	10:25

* Passenger boat daily except Sunday also calls at Wing Point and Creosote in both directions.

Fletcher Bay - Brownsville
Ferry Hiyu
12 Minute Crossing
EFFECTIVE JUNE 1

Lv. Fletcher Bay	Lv. Brownsville
7:55 am	8:30 am
9:35	10:25
11:30	12:00
1:30 pm	2:00 pm
2:45	3:40
4:35	5:35
6:30	7:20

WHIDBY ISLAND

Mukilteo - Columbia Beach
Ferry Vashon — Dining Service
15 Minute Crossing
Subject to Change June 16

Lv. Mukilteo	Lv. Columbia Beach
*6:00 am	*5:30 am
7:00	6:30
8:00	7:30
9:00	8:30
10:00	9:30
11:00	10:30
12:00	11:30
1:00 pm	12:30
2:00	1:30
3:00	2:30
4:00	3:30
5:00	4:30
6:00	5:30
7:00	6:30
8:00	7:30
9:00	8:30
10:00	9:30

SUNDAY ONLY
| 11:00 pm | 10:30 pm |

*Monday Only.

Port Townsend - Keystone
Ferry Kitsap
35 Minute Crossing

Lv. Port Townsend	Lv. Keystone
7:10 am	8:10 am
9:00	10:10
11:10	12:10 pm
1:10 pm	2:10
3:10	4:10
5:10	

BLACK BALL LINE
Colman Ferry Terminal
MAin 2222
SEATTLE

The ferries in these photographs are not identified. Above, the ferry has not quite arrived at the dock. The waves of beautiful Puget Sound crash against the beach to the north of the dock. This ferry is on one of the runs from Kingston to Edmonds, which usually took, and still take, about 25 minutes. The below photograph shows a ferry that has arrived, seen from the south side. Boats are tied to a float next to the dock. Kids and adults would fish from the float. Those who did not have a boat got their sea legs by standing on the float. (Both, courtesy of Edmonds Historical Museum.)

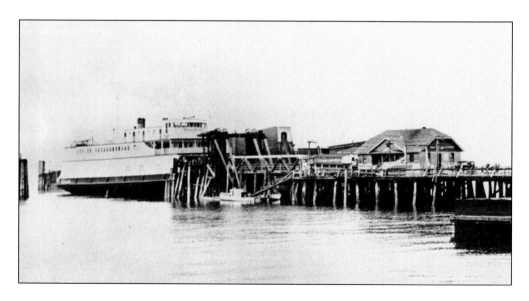

The first railway station in Edmonds was on the west side of the railroad tracks, facing east toward the city of Edmonds and beyond. The town was very small. A resident of Edmonds at that time would never have guessed that the town's growth would fill up the landscape as it has. (Courtesy of Mark Sundquist.)

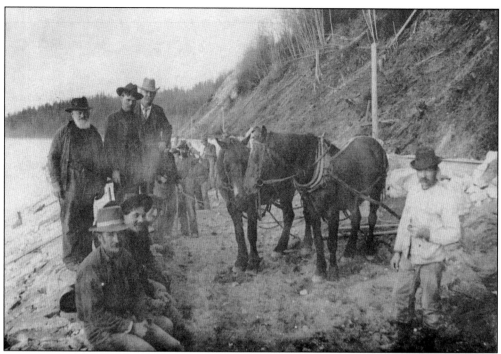

In these late-1890s photographs, workers are adding more tracks to exiting railroad lines. Laying tracks, rails, and the ties to join them was exhausting work. John Lund may be the man on the far left in the above photograph. Lund was one of the town's founding fathers. He married Matilda Deiner and took on the raising of her five children after their father died. The family lived five miles north of Edmonds, in what today is Meadowdale. In the below photograph, surveyors measure distances and check the levels of the tracks. (Both, courtesy of Edmonds Historical Museum.)

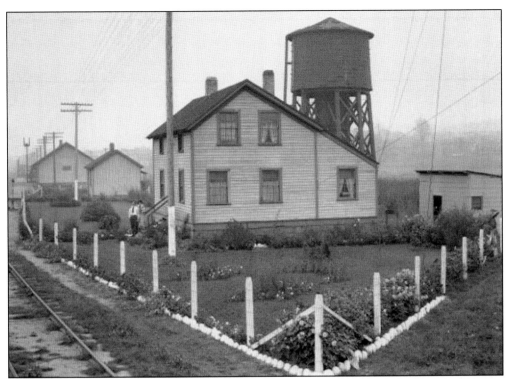

The photographs on this page show the Great Northern Railway residence and station and a water tower. In the above photograph, beyond the structures, the rest of Edmonds is visible to the east. This means that these buildings faced west, across the street from the first railway station. The tracks head north toward Everett. The below photograph shows the same residence and station. The water tower is seen up close. In this photograph, the tracks head south toward Seattle. Some of the hills of Edmonds are visible to the east, beyond the buildings. Edmonds looks rather barren of homes and businesses in these photographs. (Both, courtesy of Edmonds Historical Museum.)

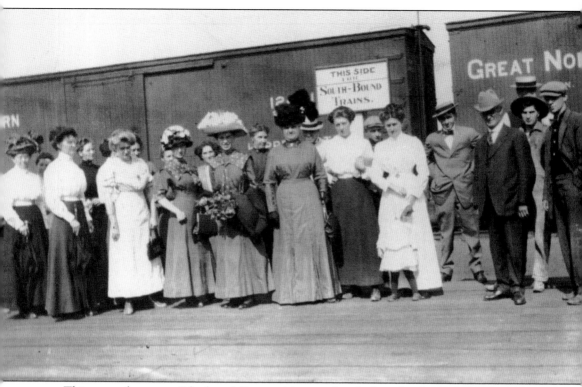

This group, known as "the bunch," are waiting on the platform for the train heading to either Seattle or Everett in 1912. This group may have taken the train daily. All had been classmates and close friends at Edmonds High School. The bunch is identified as those in the front row, from left to right, Shirley Mathews, DeWitt Wiley, Philena Shank, Ethel Proctor, Jesse Wasser, Elsie Seeley, Frances Anderson, Eathel Engel, Marie Schreiber, Lyle Proctor, Wayne Beeson, and his son. (Courtesy of Edmonds Historical Museum.)

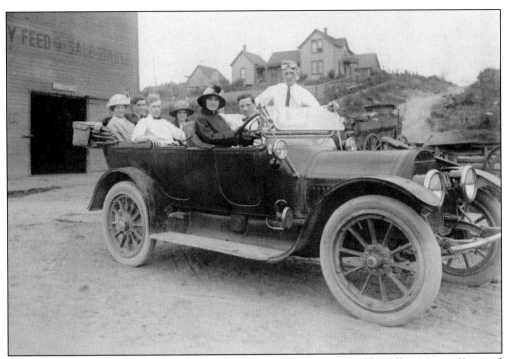

The very first car to be purchased and driven in Edmonds was owned by Allen Martin Yost and his family. It appears to be parked in front of the Yost garage. Yost also later sold automobiles, as well as repaired them. (Courtesy of Edmonds Historical Museum.)

Frances Anderson and nine of her friends, including a young girl, are pictured in her automobile. This location appears to be near Meadowdale, five miles north of Edmonds' downtown. The dock and fishing pier can be seen in the background. (Courtesy of Edmonds Historical Museum.)

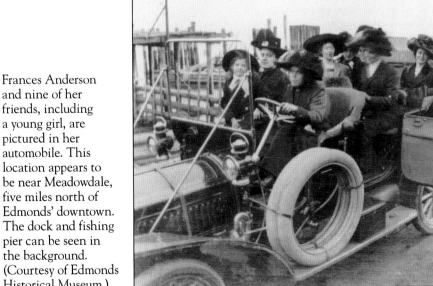

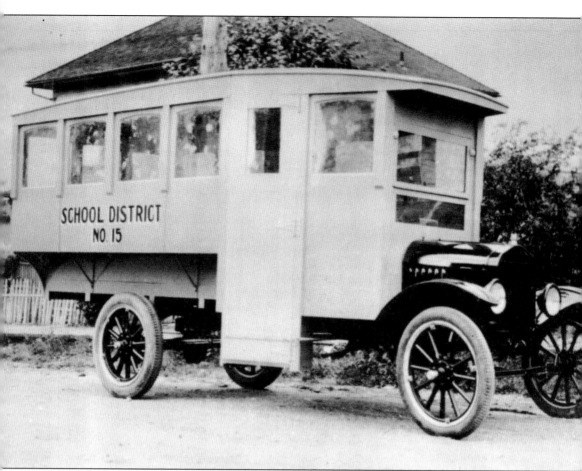

This was one of the first school buses for the Edmonds School District No. 15. It resembles a house on wheels. The bus is parked in front of a house, the roof of which is visible at the top. It must have been fun to ride in this bus to and from school every day. (Courtesy of Edmonds Historical Museum.)

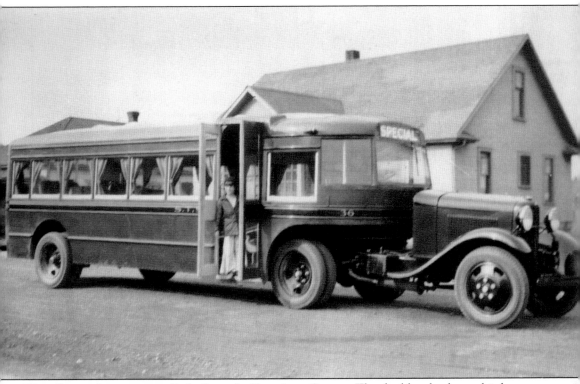

The alligator bus was actually built at the Yost Auto Garage. The double wheels on this bus look like they were meant for a semi truck. But the bus carried children, after all, the precious cargo of the families of Edmonds. Note that the windows on the bus have curtains. (Courtesy of Edmonds Historical Museum.)

The Yost Garage and Motors, aka the Edmonds garage and motors, is shown here. The sales department was located in the front, beyond the left frame of this photograph. The garage was at the rear. At right, on the second floor of this building, is where the buses were parked. Edmonds had a bus service from this location to Seattle. Also visible is a Chevron gas station. This photograph was taken in the late 1950s. (Courtesy of Edmonds Historical Museum.)

Seven

DOWNTOWN STREETS AND BUSINESSES

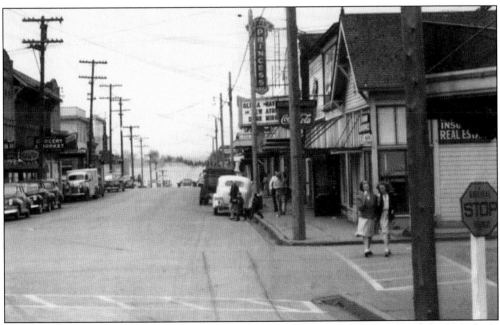

The view in this 1940s photograph of Main Street looks west to Puget Sound and the ferry dock. On the north (right) side of the street are Hubbard Real Estate and Insurance, Bienz Confectionery, and the Princess Theater farther down the street. Visible on the south (left) side are the Edmonds Bakery, which is still there, and a grocery store. (Courtesy of Edmonds Historical Museum.)

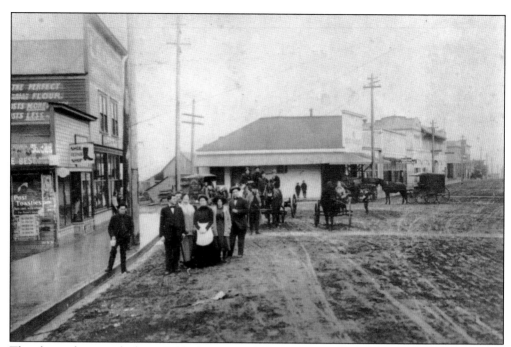

The above photograph shows Fifth Avenue and George Street (later known as Main Street) in 1912. The persons identified on the back of the photograph are Joe Theroux, L.C. Engel, Zetta Fourtner Engel, Eathel Engel Beeson, Alton Arrowwood, Wayne Beeson, ? White (girl from Meadowdale), Ed Martensons, Sam Yost, Ralph Bartlett, Floyd Woodfield, Ernest Fourtner Engel, Frank Milspaugh, George McGowan, Elsie Seeley Mathews, Charley Mathews, Norma and Ray Doty, and Mr. and Mrs. Dewey. The below photograph shows the same intersection, Fifth Avenue and Main Street, in the 1940s. At left is L.C. Engel's Shoes and Dry Goods, in the Engle Building, built in 1904. Across the street are Edmonds Otto's Meat Market, Sherrod Bros. Hardware and Furniture, the Beeson Building, and Edmonds Cash Store. (Both, courtesy of Edmonds Historical Museum.)

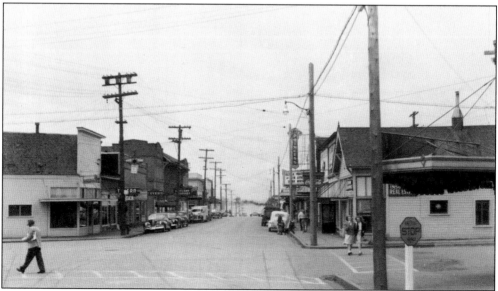

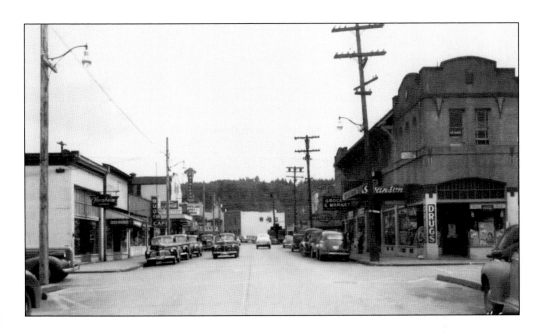

These photographs show Main Street, in a view looking east from Fourth Avenue and slightly beyond Fifth Avenue. Main Street goes in a diagonal to the left from Fifth Avenue, so a driver might feel as though his or her car would run right into the building in the distance, to the right (south) side of the street. The businesses on the north (left) side of the street are Florsheim Shoes, a flower shop, Bud's Café, and, past an alley, the Princess Theater. Across Fifth Avenue was a Safeway grocery store. Later, when Safeway moved to a new location, a gift shop called Peggy Harris's took over that space for many years. On the right side of the street are Swanson Drugs, Puget Sound Light, and other stores. (Both, courtesy of Edmonds Historical Museum.)

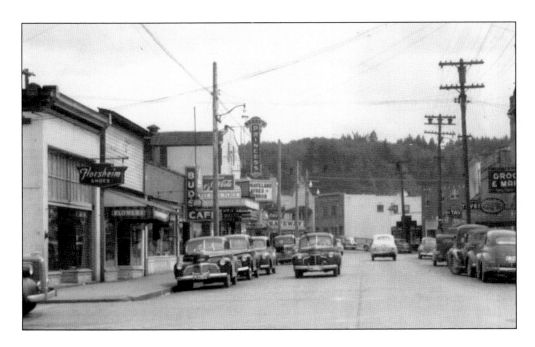

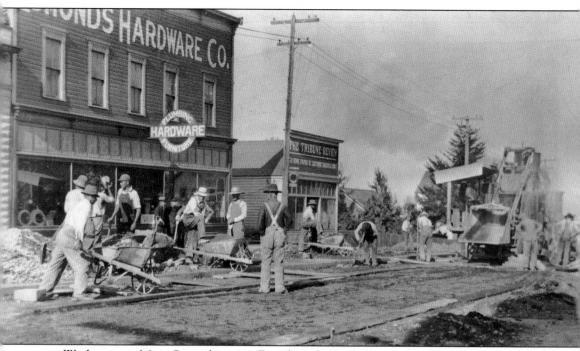

Workers pave Main Street between Fourth and Third Avenues in February 1917. Edmonds Hardware Company (now Chantrelle's Restaurant) and the Tribune Review building are visible. The view in this photograph faces west. (Courtesy of Edmonds Historical Museum.)

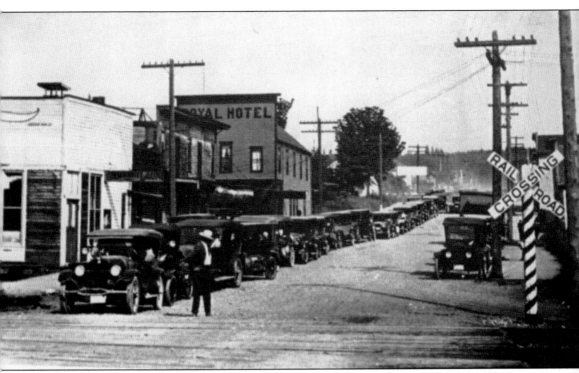

Traffic waits for the next ferry at the foot of Main Street at Railroad Avenue. Visible at left are Crescent Laundry and the Royal Hotel. This is an extension of the photograph featured on the cover of this book. The cars are backed up on Main Street to the east. The photograph was taken around 1927. (Courtesy of Edmonds Historical Museum.)

The future Third Avenue South is being graded in 1915. The D.C. Campbell house, at 221 Third Avenue, is on the far left. Also seen here are the V.J. Kelley barn (center) and the Everton house and barn (right). The second person from the right is Cid Kelley; at far right is Orville Kelley. (Courtesy of Edmonds Historical Museum.)

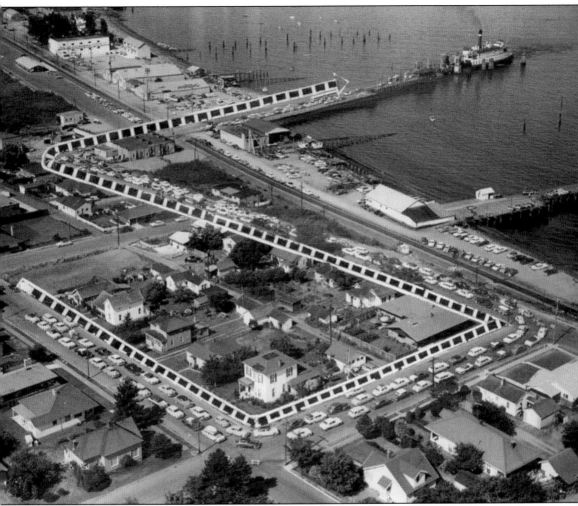

The Edmonds waterfront is seen here in 1958. The dotted, zigzag arrow added to the photograph shows the route of the ferry traffic, all the way to the dock and to the ferry itself. The view in the photograph faces south. (Courtesy of authors.)

Very different parts of Edmonds are seen in these 1948 photographs. The above photograph depicts Front Street, which became Sunset Avenue that year. Sunset Avenue goes north from Main Street, to Caspers Corner and then east on Caspers Way near North Third Avenue, the northern side of the downtown bowl. Now, as then, Sunset Avenue was a favorite place to see spectacular views of the sound and the peninsula across the water, only about seven miles as the seagull flies. The below photograph shows 205th Street and Aurora Avenue on Highway 99 in 1948. Highway 99 curves gently around to the north to the Canadian border, and south to the Mexican border. The road heading off to the left is Edmonds Way, which goes west to Edmonds. (Both, courtesy of Nellie Dondino Cant.)

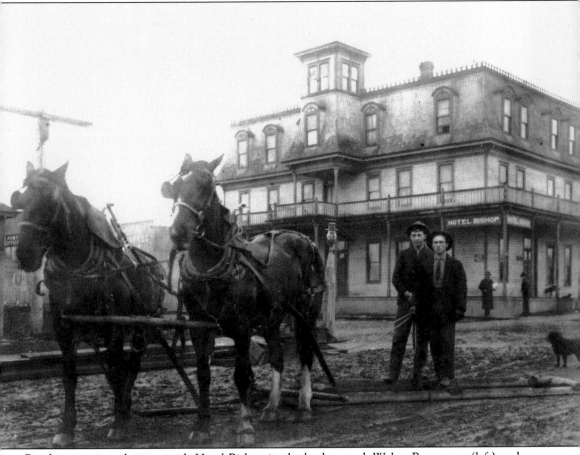

Road paving is under way, with Hotel Bishop in the background. Walter Rynearson (left) and Frank Hough are leveling Bell Street at the corner of Second Avenue in 1902. Just visible behind the horses are the post office, a lamppost, and Edmonds Stable and Feed. The northeast corner of Second Avenue and Bell Street is today the site of Harbor Master Condos, 200 Second Avenue North. (Courtesy of Edmonds Historical Museum.)

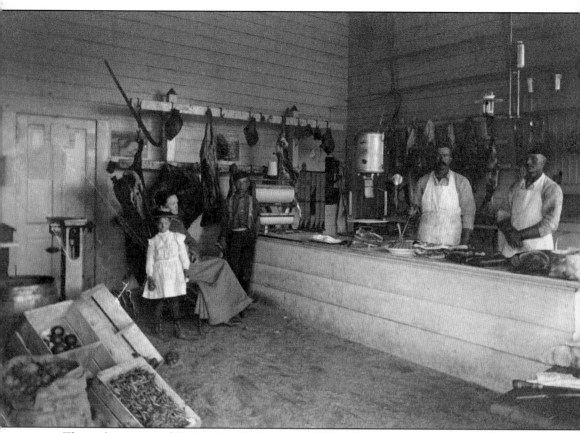

This is the interior of Otto's Meat Market around 1902. The store stood on the southwest corner of Fifth Avenue and Main Street. Shown here are, from left to right, Clara Belle Otto, Mattie (Mrs. J.N.) Otto, Paul Oliver Otto, James Nathan "Jim" Otto, and "Uncle Fred." (Courtesy of Edmonds Historical Museum.)

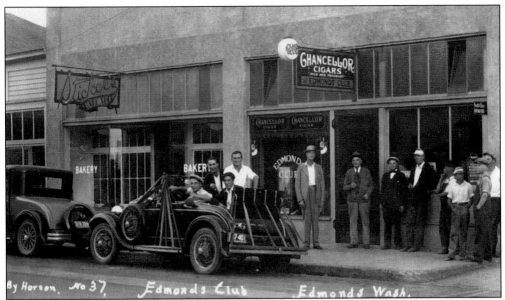

Seen above is the Edmonds Club and Sticker's Bake Shop in 1929 (based on the license plate). The men in the car are Eugene Johnson (behind the wheel), Charlie Little, Bud Little, and Orville Milspaugh (standing in rumble seat). Written on the back of the photograph is "possibly Fred Fourtner in black cap to the right." Shown below is Schumacher Groceries, located at Fourth Avenue and Main Street. In front of the store are three unidentified adults and three unknown children. In addition, two men sit in the delivery wagon, with the horse ready to go. The grocery's sign is placed over the sidewalk so that no one misses it. Schumacher's sold groceries, furnishings, and shoes. It was a kind of general store. (Both, courtesy of Edmonds Historical Museum.)

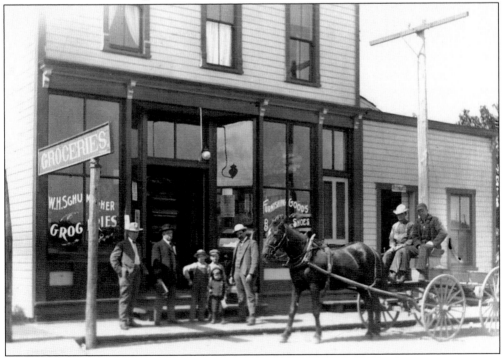

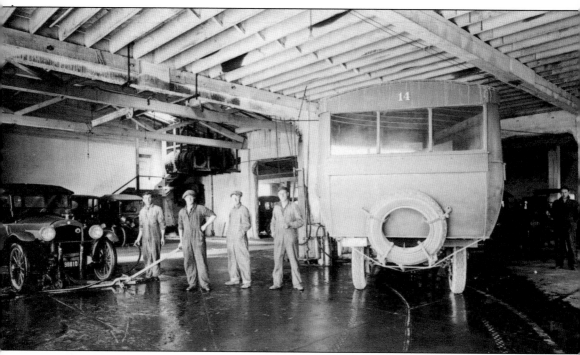

This photograph of the interior of the Yost garage shows, from left to right, Ed Yost, Harry Cogswell, Charlie Arrowood, and Russ Corney. Cogswell later owned the Shell gas station across Dayton Street from the garage. (Courtesy of Edmonds Historical Museum.)

Bienz Confectionery is seen here in 1948, with Mary Hammond (left). This was the place to go for 5¢ or 10¢ sodas. Ada Bienz and Hammond used to keep old coffee cans in the ice cream freezer behind the counter, in which frozen water was kept. Then, when they made cherry Cokes or other mixed flavors of soda, the ice would be chipped from the cans with an ice pick. The store also had a great selection of candy bars, comic books, and other fun things to look at, read, and purchase. In the below photograph are Edmonds paper boys in 1948, They delivered the *Seattle Times* and the *Seattle Post-Intelligencer* papers on their bikes. (Both, courtesy of Facebook group "You Know You're From Edmonds, When")

Bill and Dave Crow, father and son, were the friendly owners of Crow Hardware. Customers could get any hardware item from them, and they were always helpful in explaining how to use and hold certain tools. (Courtesy of Edmonds Historical Museum.)

Eight

PROMINENT EDMONDS CITIZENS AND ATHLETES

The Engel girls, Jessye (left) and Lola, seen here as youngsters, went on to become business people in Edmonds. Jessye married Harry Cogswell, and together they owned a building that housed a real estate office, a tavern, and a Shell gas station. She ran the real estate office, and Harry had the Shell station. The tavern is still there and is now a pub. (Courtesy of Edmonds Historical Museum.)

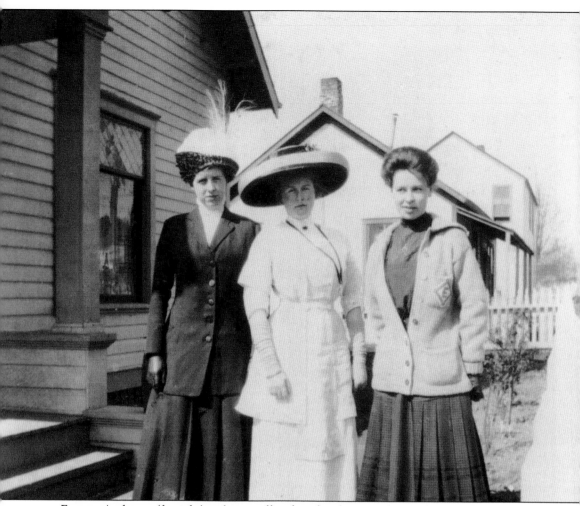

Frances Anderson (far right) and some of her friends, who were also teachers, are pictured in front of the Anderson house. Frances was born Frances Elizabeth Anderson in Drummond, Montana, on November 16, 1890. (Courtesy of Edmonds Historical Museum.)

The above postcard photograph shows Edmonds Athletic Club. A girls' basketball team and coach pose in the below photograph in 1909. Shown are, from left to right, an unidentified teacher, Marie Schreiber, Myrtie Rynearson (later Otto), Lester Wilson, Frances Anderson, Elsie Seeley, and an unidentified teammate. The team played in what is now the Masonic temple building. A newspaper article from February 12, 1909, is attached to the back of the photograph. It reads: "About 30 young ladies of this city have organized an Athletic Club and have elected Leslie Wilson physical instructor and Edger Smith manager. They will soon have a basketball team and will be ready to have a trial game." (Both, courtesy of Edmonds Historical Museum.)

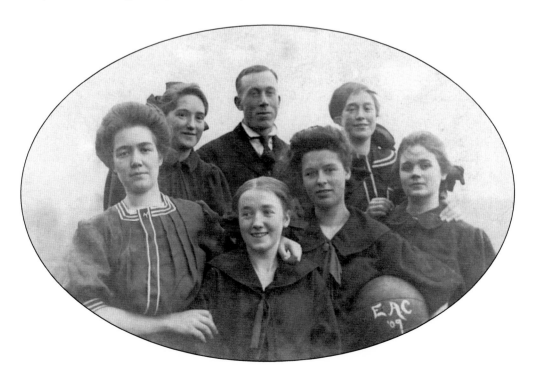

These photographs depict Edmonds Athletic Club girls' basketball teams. The above photograph, taken in 1910, shows, from left to right, (first row) Mildred (or Mary) Dorgan, Noel Smith (mascot), and Eathel Engel; (second row) Myrtie Rynearson Otto and Frances Anderson; (third row) Marie Schreiber, Mr. Smith, and Isie Seeley. The 1911 Edmonds Athletic Club girls' team picture (below) includes, from left to right, Mr. Smith, unidentified, Myrtie Rynearson Otto (third from left), two unidentified, and Frances Anderson (right). (Both, courtesy of Edmonds Historical Museum.)

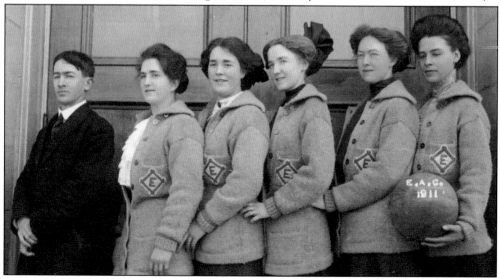

Theresa "Cy" Reynolds stands on the back porch of the Olympic Hotel. Later in life, Reynolds apparently owned and ran the hotel for several years. The Olympic was originally the Hotel Bishop. Often, the city council would meet there to discuss business. (Courtesy of Edmonds Historical Museum.)

In 1938, Jennie Gertrude Osborn Perrin told her husband, Carl, "If I'm going out in the sticks, I'm going to start me a town." She went to the courthouse and paid 10¢ to register a name for their acreage. Ever since, it has been known as Perrinville, located about five miles northeast of downtown Edmonds. Although Perrinville never did become its own town, it did get a post office and some businesses. (Courtesy of Edmonds Historical Museum.)

These two photographs show Gertie and Carl "Skip" Perrin, after they got married in 1932 (right) and after they had their one son, Carl "Skip" Jr., in 1933 (below). They are in their late thirties or early forties, but they look younger. After 34 years of marriage, Carl Sr. died on June 9, 1965. Gertie continued on, creating other businesses. She passed away on October 4, 1991, at the age of 98, and she was feisty to the end. Their son died in Las Vegas on May 18, 2010. Gertie was close friends with Helen Reynolds, a prominent photographer for decades in downtown Edmonds. A photograph of Carl Sr. was always displayed in the window of Reynolds's photography studio, along with other photographs she had taken of people. (Both, courtesy of Edmonds Historical Museum.)

In the photograph at left are Mayor Fred Fortner (left) and Mayor Jimmy Walker of New York City in June 1928. The ship *City of Victoria* was soon to enjoy a brief prominence when Walker paid a short visit to Edmonds. He was on his way to Victoria, British Columbia. When his train arrived in Edmonds, Capt. J. Howard Payne, in a possible gambit for public relations, convinced the mayor to transfer from the train at Edmonds and continue his trip to Victoria on the *City of Victoria*. Walker opted to stroll from the train to the wharf, accompanied by eager civic leaders scampering at his side. The below photograph shows Mayor Fourtner and his mother, Elsie Hathaway Fourtner. (Both, courtesy of Edmonds Historical Museum.)

Pictured here is Myrtie Rynearson Otto. She was in high school classes with Frances Anderson and on the basketball teams between 1909 and 1911. She owned a small store in Edmonds, not far west of the Princess Theater. (Courtesy of Edmonds Historical Museum.)

The above photograph shows Mayor Paul McGibbon (left) with Fred Fourtner (center) and Matt Engels, sometime after McGibbon became mayor of Edmonds. Fourtner, mayor for two terms before McGibbon, stayed involved in the Edmonds council and other city services. McGibbon was mayor for one and a half terms, from 1949 until his death in June 1955. He was the youngest of five living children. Before being elected mayor, McGibbon served the City of Edmonds in various capacities, and, just before his election, he was on the city council. Below, Mayor McGibbon of Edmonds (left) poses with, from left to right, Mayors Townsend of Snohomish, Prism of Anacortes, Easter of Montesano, Nichols of Longview, and Trumble of Yelm. (Both, courtesy of Edmonds Historical Museum.)

Nine

DOWNTOWN CHURCHES IN EDMONDS

The First Baptist Church, which was located at North Fourth Avenue and Bell Street, is seen here around 1950. This church building has been at this site longer than any church has occupied a location in Edmonds. The church is now used for another denomination. (Courtesy of Edmonds Historical Museum.)

This c. 1906 photograph shows the Holy Rosary Catholic Church, on the north side of Seventh Avenue North and Daley Street. The Holy Rosary mission church was built in 1905. A second building had been there for decades, until the church outgrew its space with congregants and moved around the corner, about halfway between Daley and Casper Streets. (Courtesy of Edmonds Historical Museum.)

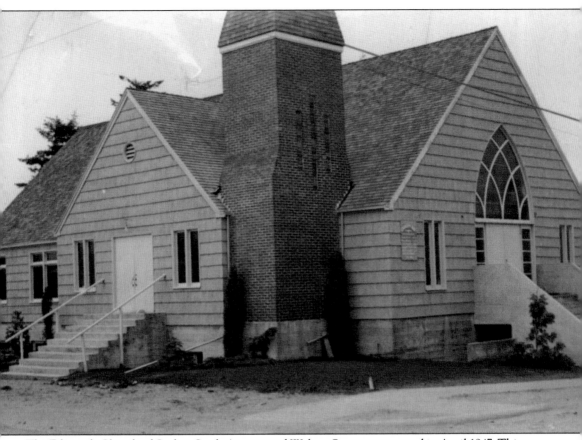

The Edmonds Church of God, at Sixth Avenue and Walnut Street, was started in April 1947. This church building was moved to another location, at 420 Fifth Avenue North, and was attached to business offices. These days, it appears that the building still has a church associated with it and that services are conducted there. (Courtesy of Edmonds Historical Museum.)

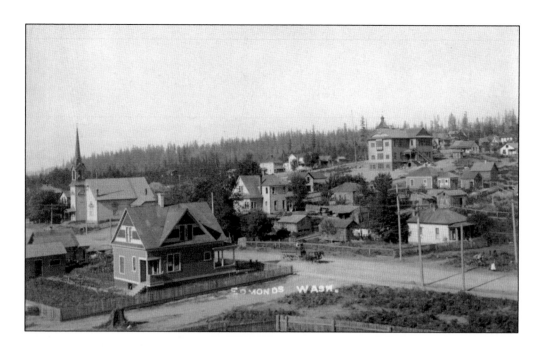

Shown above is a postcard photograph of Sixth Avenue South before 1906. The Edmonds Congregational Church is at far left. Also seen are the Dewey house, left of the parsonage, Macelroy Undertaking Parlor, and Edmonds Grade School along Dayton Street. Note the horse and wagon and, in the middle of the road at lower left, a tree stump. Up on the hill is the grade school building at Seventh and Main Streets. The Congregational church, at Sixth Avenue North and Dayton Street, would eventually become the American Legion post for Edmonds, known as the Frank Friese Post. The below photograph shows the Congregational church Sunday school class. (Both, courtesy of Edmonds Historical Museum.)

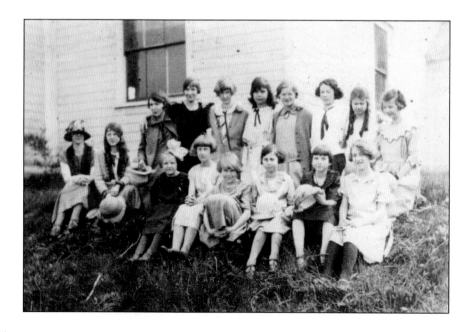